*Masterpieces of Baroque Painting
from the Collection of the
Sarah Campbell Blaffer Foundation*

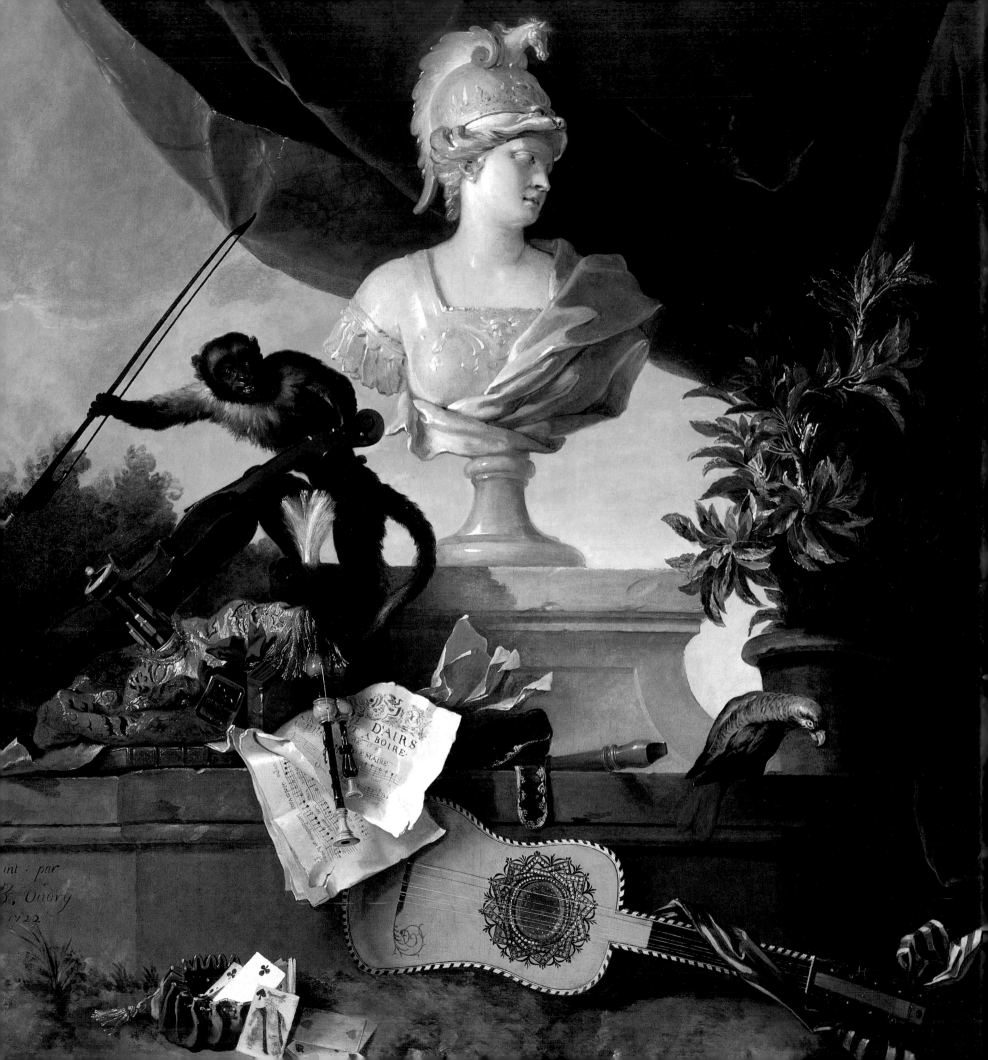

int · par

B. Oüdry

1722

D'AIRS
A BOIRE
LE MAIRE

Masterpieces of Baroque Painting

from the Collection of the

Sarah Campbell Blaffer Foundation

George T.M. Shackelford

with essays by
Colin B. Bailey
Susan J. Barnes
Katherine T. Brown

THE MUSEUM OF FINE ARTS, HOUSTON

Publication of this catalogue has been made possible by a generous grant from the Sarah Campbell Blaffer Foundation.

This exhibition was organized by the Museum of Fine Arts, Houston. The exhibition is made possible by a generous grant from the Sarah Campbell Blaffer Foundation and by the trustees of the Museum of Fine Arts, Houston.

Masterpieces of Baroque Painting from the Collection of the Sarah Campbell Blaffer Foundation is published by the Museum of Fine Arts, Houston in conjunction with the exhibition on view at the museum from October 4, 1992 through January 1, 1993.

Library of Congress Cataloging in Publication Data is found at the back.

ISBN 0-89090-056-6 (cloth)
ISBN 0-89090-055-8 (paper)

Published in 1992 by
The Museum of Fine Arts, Houston
Houston, Texas

Contents

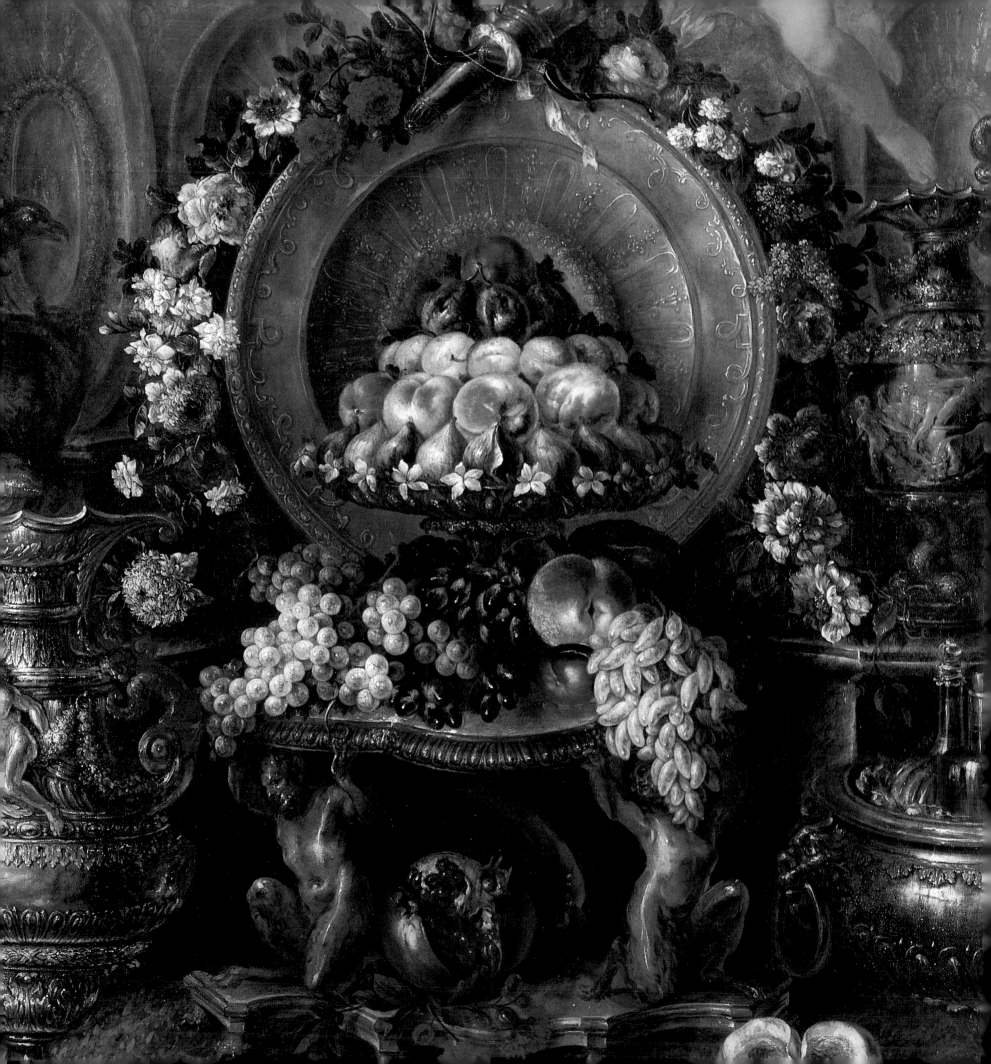

Foreword

This splendid exhibition of Old Master paintings pays tribute to the remarkable vision of one of Houston's most extraordinary women, Sarah Campbell Blaffer. Mrs. Blaffer, born in 1885 in Waxahachie, Texas, grew up in Lampasas and Houston. In 1909, she married Robert Lee Blaffer, who went on to be one of the founders of Humble Oil. On her wedding trip to Paris, Mrs. Blaffer first became aware of the great power of works of art. The Museum of Fine Arts, Houston, bears the mark of her intense appreciation of artistic mastery: works by Giovanni di Paolo, Mabuse, Hals, Canaletto, Boucher, Renoir, Cézanne, and Degas hanging in our galleries attest to her outstanding taste and are the proof of her generosity to this city.

At Mrs. Blaffer's death in 1975, the foundation that bears her name embarked on an ambitious program of collecting masterworks of European painting from the Renaissance to the end of the eighteenth century. The collection was formed with the aim of gathering works that would illustrate the various genres and styles of painting produced in European societies from the fifteenth to the eighteenth centuries. These have been exhibited throughout the state of Texas and indeed throughout the nation, bringing fine works of art to regional and local institutions completely free of charge. In the past sixteen years, the foundation has presented more than two hundred exhibitions of Netherlandish, Italian, and British paintings, and the graphic arts of Goya and Hogarth; these have enriched the artistic life of this state beyond measure. The foundation has also lent most generously to major exhibitions organized by museums in the United States and Europe.

On behalf of the Museum of Fine Arts, Houston, I want to thank the Board of Trustees of the Sarah Campbell Blaffer Foundation for kindly allowing us to present this exhibition of a selected number of paintings from the collection. Most notably, E. Joseph Hudson, Jr., who is also a trustee of this museum, was instrumental in helping us to formulate the exhibition proposal and to secure important funding for the project; he has also lent two beautiful paintings to the exhibition.

Mr. Spencer Samuels of New York City, a longstanding friend and advisor to the foundation, has been invaluable in the selection of the works of art and in the assembly of information for this catalogue.

The exhibition was organized by our Curator of European Painting and Sculpture, George T. M. Shackelford. We are grateful to him and to the team of scholars from Texas institutions who kindly contributed to this volume: Colin B. Bailey, Senior Curator of the Kimbell Art Museum, Fort Worth; Susan J. Barnes, Chief Curator, The Dallas Museum of Art; and Katherine T. Brown, Professor Emerita of Rice University, Houston.

Our thanks go, finally, to the trustees of the Museum of Fine Arts, Houston, who under the leadership of Alfred C. Glassell, Jr., Chairman, have contributed personally to make the handsome presentation of this exhibition possible.

Peter C. Marzio
Director

Acknowledgements

In 1990, The Museum of Fine Arts, Houston, first approached the Sarah Campbell Blaffer Foundation with the idea of presenting a selective but comprehensive survey of its rich collections of Old Master painting. Since that time, I have benefited greatly from the advice and help of many organizations and individuals.

First and foremost, I would like to thank the trustees of the Sarah Campbell Blaffer Foundation for their support of this exhibition and its catalogue. The confidence that they have shown in the museum's proposal to exhibit these paintings in a novel and, we hope, meaningful way has meant much to the success of the project.

Spencer Samuels has been a constant source of advice during the organization of the exhibition. I would like to extend my thanks to him for all his help. The Houston-based staff of the Blaffer Foundation has responded to all my requests with generosity. I would like to extend my thanks to former foundation directors Terrell Hillebrand and Rosilyn Alter, as well as to Marilyn Steinberger, administrator.

For their willingness to share their expertise and for their contributions to this catalogue, I owe a great debt to my friends and colleagues Colin Bailey, Susan Barnes, and Katherine Brown. We are grateful to the scholars who have researched the collection of the Blaffer Foundation for previous and forthcoming publications, including Christopher Wright, Teresio Pignatti, Martin Butlin, and Alastair Laing. I would also like to thank those museum professionals, scholars, collectors, and others who helped me with the preparation of the exhibition and the organization of the catalogue: Claire Barry, Beverly Brown, Alan Chong, Mary Tavener Holmes, William F. Jordan, Otto Naumann, Christopher Robinson, Guy Stair Sainty, Alan Salz, Gerry Scott, David Steel, Peter Sutton, Alan Wintermute, and Jimmy and Jessica Younger.

At the Museum of Fine Arts, Houston, I would like to thank the following people who made this project possible: Emily Neff and Ashley Scott, curatorial assistants, and Wanda Allison and Clifford Edwards, curatorial secretaries, who managed the checklist, labels, and other aspects of the exhibition; Charles Carroll, Kathleen Crain, Phyllis Hastings, Wynne Phelan, and the Registrar's office; Jack Eby and the Design and Productions departments; Gregory Most, Karyn Galetka, and Tom DuBrock, who helped secure additional transparencies for the book; Margaret Skidmore, who worked diligently to obtain funding for the exhibition; Tammie Kahn and Alison Eckman, who publicized the show; Celeste Adams, who assured this catalogue's wide distribution; and Mary Christian, who edited the catalogue and supervised its production. Peter Layne has contributed the catalogue's handsome design.

During the time that I have been working on this project, my life has been enriched by many friends and loved ones. To the memory of the first of these, Moore Murray, I would like to dedicate this work.

George T. M. Shackelford
Curator of European
Painting and Sculpture

Introduction

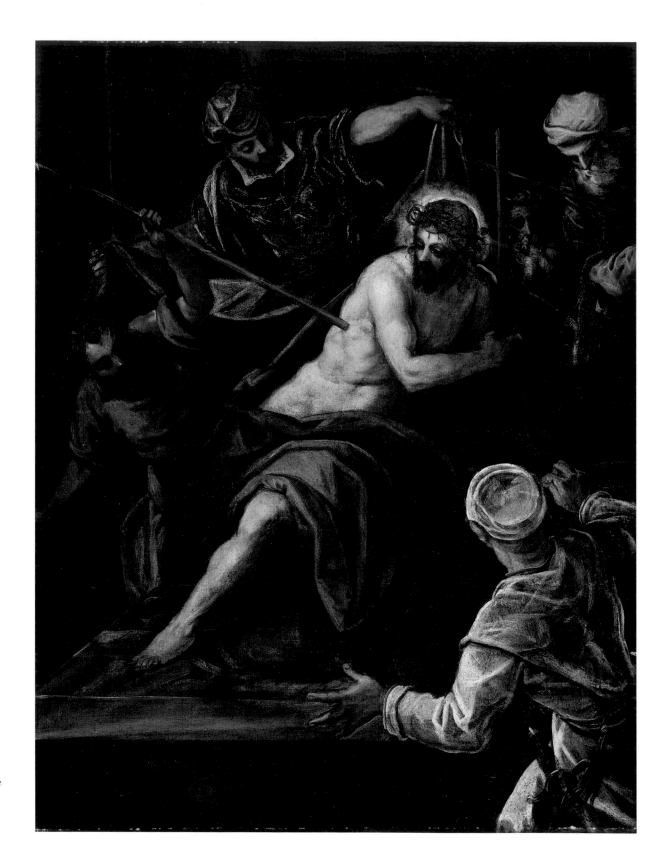

Plate 1. Jacopo Robusti, called
Tintoretto (Venice 1519-Venice
1594), *The Mocking of Christ*,
c. 1580s, oil on canvas,
61⅞ x 41¼ in.

Introduction

GEORGE T.M. SHACKELFORD

One hundred years ago, a young painter declared that "before it is a battlehorse, a nude woman, or some anecdote," a painting was first and foremost "a flat surface covered with colors in a certain order."[1] In the early twentieth century, this notion of the supremacy of form above content echoed throughout Europe. Rejecting the importance traditionally given to the subject matter of a work of art, vanguard artists and the historians and critics that followed them imposed a new sort of order, one that suppressed interpretation of a work of art on the basis of subject matter.

The critical subordination of subject matter has left us, in the last years of the century, at pains to understand the conventions of the art of the past. Until the nineteenth century, paintings and even the artists that produced them were classified by subject type, that is, according to the "hierarchy of the genres." This well-established doctrine declared that the painting of histories—stories from the Bible, from ancient history, or from literature and myth—took precedence over all other forms of painting. Thus the so-called "minor genres" of still life, landscape, and popular genre, as well as the somewhat special category of portraiture, were thought to be less worthy of the great artist, less deserving of the attention of the connoisseur, or, as one theorist phrased it, merely "recreational aspects of art."[2]

Audiences in the twentieth century have lost sight of the relationship between the genres. Many of us, willing to accept anything as a potential subject for art, are unaware that such a system of relative values ever existed. Inspired by the theory and practice of the baroque period, therefore, we have chosen to organize the paintings in this exhibition and catalogue by subject matter, as it was understood and defined between the end of the Renaissance around 1580—when the "minor genres" began to emerge with confidence—and the birth of modern art at the close of the eighteenth century. Still lifes, landscapes, genre paintings, portraits, and paintings of sacred and profane history are presented together in the exhibition and discussed in separate essays in this book. In keeping with the international flow of ideas between artists in baroque Europe, the paintings are also exhibited with little regard to historical chronology or country of origin. We hope that this will allow the viewer or the reader to pursue the study of each genre, as it is reflected in the Blaffer Collection, in a way that would not be possible in a more conventional museum installation or catalogue. By reinstating the values of an earlier age, this exhibition may help us to recapture its understanding.

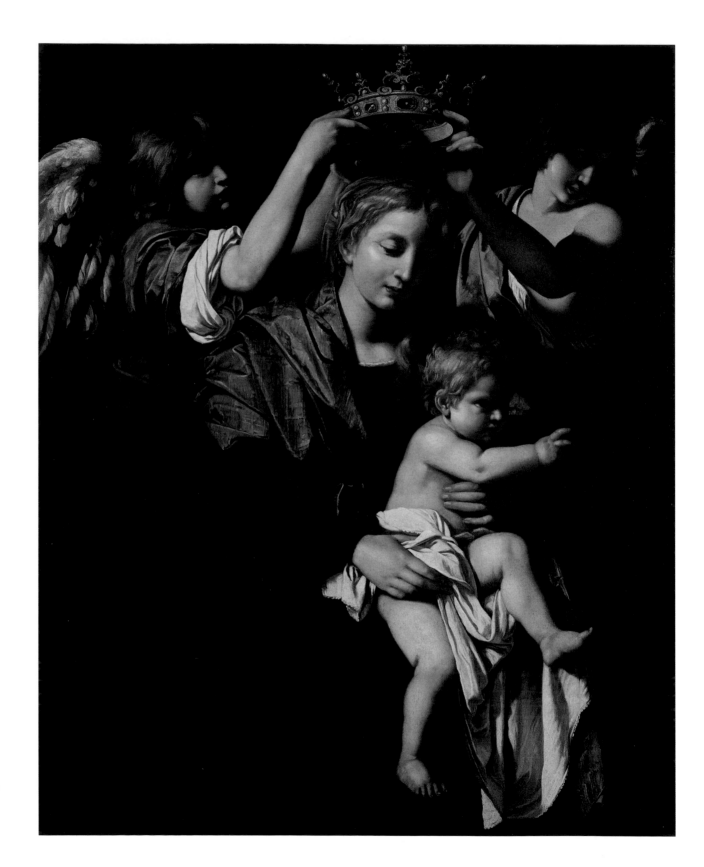

Plate 2. Bartolomeo Cavarozzi
(Viterbo c. 1590-Rome 1625),
Virgin and Child with Angels,
c. 1620, oil on canvas,
61⅛ x 49¼ in.

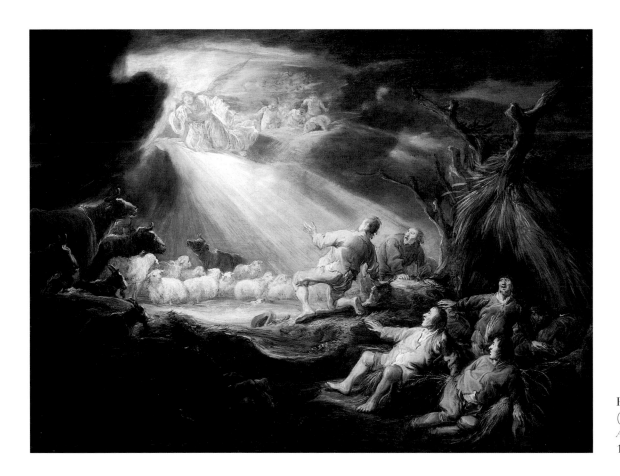

Plate 3. Benjamin-Gerritsz. Cuyp (Dordrecht 1612-Dordrecht 1652), *Annunciation to the Shepherds*, after 1633, oil on canvas, 33 x 45⅞ in.

In the Middle Ages and the Renaissance, virtually all important painting and sculpture treated religious subjects, specifically subjects taken from the lives of Christ, the Virgin, or the saints, or from the Old Testament. Exceptions to this rule, more frequently encountered in the art of the Italian Renaissance, included themes taken from classical mythology, such as Apollo and the Muses, the Labors of Hercules, or the stories of Venus and Bacchus. All of these subjects, whether sacred or profane, dealt with intellectual concepts through *istorie*—histories, or stories—to use the terms of the fifteenth-century theorist Leon Battista Alberti, writing in his famous treatise on painting, *Della pittura.*

Throughout the Renaissance, there were few independent paintings that did not follow from Alberti's dictum that "the greatest work of the painter is *history.*"[3] Still life, although it was painted for its own sake in ancient times, merely furnished accessory details in religious or secular narratives; landscape was hardly ever painted except as the background to biblical or mythological characters; scenes of everyday life (what we now call *genre*) were employed by history painters to illustrate moral

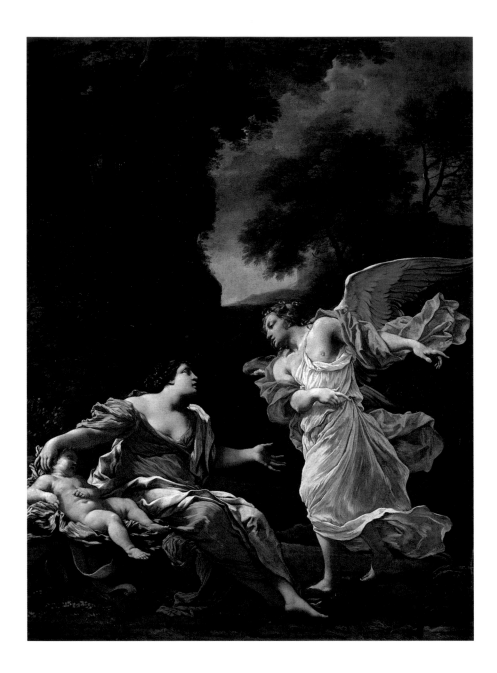

Plate 4. Michel Dorigny
(Saint-Quentin 1617-Paris 1665),
Hagar and the Angel, c. 1645-50,
oil on canvas, 55¾ x 42⅜ in.

lessons or adapted to lend realism to a famous scene. Portraiture, to be sure, stood apart as an independent order of expression, and was practiced regularly by the greatest painters, though seldom at the expense of their higher calling to historical works.

Thus, throughout sixteenth- and seventeenth-century Europe, the artists held in the highest esteem were those who aspired to the painting of scenes from sacred or profane history. Scenes from the lives of Christ or the Christian saints were perhaps the greatest in number—Tintoretto's *Mocking of Christ* (plate 1) or Cavarozzi's *Virgin and Child* (plate 2) are representative examples of Christian imagery from Italy, as the robust *Annunciation to the Shepherds* by Benjamin Gerritz. Cuyp (plate 3) displays a characteristically Northern realism—but Old Testament stories such as that of *Hagar and the Angel*, painted by Michel Dorigny (plate 4), also found favor. Scenes from classical history and mythology were only slightly less popular, and the taste for such works extended from the Mannerist period through the eighteenth century, as such works as the Flemish *Triumph of Neptune and Amphitrite* (plate 5), Carle Van Loo's *Mars and Venus* (plate 6), or Favanne's *Athena Protecting Alexander* (plate 7) affirm.

It is only at the outset of the baroque period that painters begin to develop reputations as specialists in the secular genres. Paul Bril (1554-1626), a Flemish painter active in Rome from the 1570s, became famous for his pure landscapes and seascapes, which were in turn admired by the French painters Claude Lorrain (fig. 4) and Gaspard Dughet (plate 23), likewise working in Italy; still lifes by Netherlandish artists ultimately influenced the painter Pietro Paolo Bonzi (plate 13).[4]

It is no accident that the self-conscious definition of these genres as distinct from the traditions of history painting and portraiture coincides with the founding,

across Europe, of academies of art for the teaching of drawing and painting.[5] Nearly all of these academies trained their students to be history painters; few, if any, considered still life painting or landscape to be a fit occupation of an ambitious artist. At first, many of these schools were simply expanded workshops, but with their growth and their gradual transformation into organized civic or national institutions, the value systems held by their founders were sometimes elaborated into bodies of theory.

By far the most concise and definitive explanation of the baroque period's concept of the genres and their relative importance was written by a Frenchman, André Félibien, and delivered as one of a series of lectures to the newly founded Parisian *Académie royale de peinture et sculpture* in 1667. In the well-known passage from his *Conferences* that follows, Félibien sets forth the idea that there are different forms of expression, and that there are different levels of attainment for each specialist:

> In this Art there are different workers who apply themselves to
> different subjects; it is consistent that to the degree they occu-
> py themselves with the most difficult and most noble things,

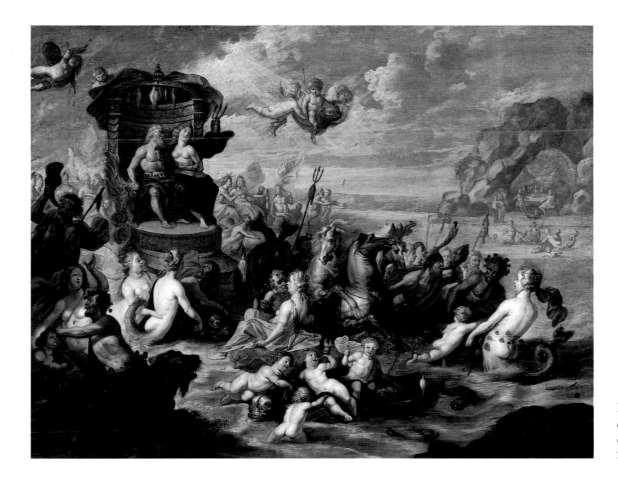

Plate 5. Flemish school, *The Triumph of Neptune and Amphitrite*, mid 17th century, oil on metal laid on board, 21½ x 28¼ in.

Plate 6. Carle Van Loo (Nice 1705-Paris 1765), *Mars and Venus*, c. 1730, oil on canvas, 32 x 26 in.

they leave behind that which is most low and most common, and ennoble themselves by means of a more illustrious undertaking. Thus he who does landscape perfectly is above another who does only fruits, flowers, or shells. He who paints living animals is more noteworthy than he who represents only those things that are dead and motionless; and since the figure of man is the most perfect work of God on Earth, it is also certain that he who makes himself the imitator of God in painting human figures, excels much more than all the rest. However, no matter that it is no mean feat to make the figure of man appear as if living, and to give the appearance of

Plate 7. Henri-Antoine de Favanne (London 1668-Paris 1752), *Athena Protecting Alexander before Darius*, c. 1725, oil on canvas, 37 x 49½ in.

movement to that which has none at all; all the same a painter who does only portraits has not yet attained perfection of the art, and cannot look forward to the honor that the wisest will receive. For this [honor], one must pass from the single figure to the representation of several figures together; one must treat history and fable; one must represent great deeds as do historians, or pleasant subjects as poets do; and rising higher still, one must know how, through allegorical composition, to clothe beneath the veil of myth the virtues of great men, and the most exalted mysteries. One calls him who acquits himself well of such undertakings a great painter. In this lies the force, the nobility, and the grandeur of this art, and it is this in particular that one must learn early, and that one must teach to students.[6]

Félibien's definition depends on the idea that the depiction of the human figure, "the most perfect work of God on Earth," is a more illustrious attainment than the rendering of unfeeling nature (as in landscape) or inanimate objects (as in still life). Many other theorists concurred. Samuel Van Hoogstraten, a Dutch aesthetician writing in 1678, referred to painters of still life as "but common footsoldiers in the field army of art." Art, he wrote,

has come to so great a misfortune that one finds the most famous collections composed mainly of paintings which would be made as a mere diversion or in play by great masters, for example, here a bunch of grapes, a pickled herring, or a lizard, or there a partridge, a game-bag, or something still less significant. Such things, although they also have their pretty qualities, are but recreational aspects of art.[7]

Van Hoogstraten, like Félibien, considered "the representation of the most memorable Histories" as "the most elevated and distinguished step in the Art of Painting which has all others beneath it."[8]

These hierarchies of values, based on Renaissance reinterpretation of classical art theory, found favor throughout Europe over the course of the seventeenth century. Although the Royal Academy was not founded in London until more than a century after its Parisian counterpart, the principles set out by Félibien were essentially those that Sir Joshua Reynolds espoused in his famous *Discourses*, the eighteenth-century equivalent of Félibien's *Conferences*.

There is an art of animating and dignifying the figures with intellectual grandeur, of impressing the appearance of philo-

sophick wisdom, or heroick virtue. This can only be acquired by him that enlarges the sphere of his understanding by a variety of knowledge, and warms his imagination with the best productions of antient and modern poetry.

A hand thus exercised and a mind thus instructed, will bring the art to an higher degree of excellence than, perhaps, it has hitherto attained in this country. Such a student will disdain the humbler walks of painting He will leave the meaner artist servilely to suppose that those are the best pictures, which are most likely to deceive the spectator. He will permit the lower painter, like the florist or collector of shells, to exhibit the minute discriminations, which distinguish one object of the same species from another; while he, like the philosopher, will consider nature in the abstract, and represent in every one of his figures the character of its species.[9]

Discussing genre painting, Reynolds referred to "the painters who have applied themselves more particularly to low and vulgar characters, and who express with precision the various shades of passion, as they are exhibited by vulgar minds (such as we see in the works of Hogarth)." They deserve praise, he wrote,

but as their genius has been employed on low and confined subjects, the praise which we give must be as limited as its object. The merry-making, or quarelling, of the Boors of Teniers the Battle-pieces of Bourgognone, the French Gallantries of Watteau, and even beyond the exhibition of animal life, to the Landscapes of Claude Lorraine, and the Seaviews of Vandervelde. All these painters have, in general, the same right, in different degrees, to the name of painter, which a satirist, an epigrammatist, a sonneteer, a writer of pastorals, or descriptive poetry, has to that of a poet.[10]

Plate 8. Benjamin West (Springfield 1738-London 1820), *The Son of Man in the Midst of the Seven Golden Candle Sticks, Appearing to John the Evangelist, and Commanding him to Write (John called to Write the Revelation)*, 1797, oil on five sheets of paper mounted on canvas, itself mounted on panel, 57½ x 25¼ in., on panel 57⅞ x 26½ in.

Like Félibien and Van Hoogstraten before him, Reynolds stressed the anti-sensual, intellectual constituent of art as that which distinguishes the grand from the petty. It is ironic that Reynolds—the greatest English portraitist of his time—declared that "in the same rank, and perhaps of not so great merit, is the cold painter of portraits."[11]

The judgments of Félibien, Van Hoogstraten, or Reynolds set the standard for much art theory of the seventeenth, eighteenth, and nineteenth centuries, but it is unclear to what extent their ideas reflected the beliefs of artists or affected their practice. Certainly no great history painter refused to associate or even collaborate with a painter of still life or landscape. Perhaps more importantly, the system of values that

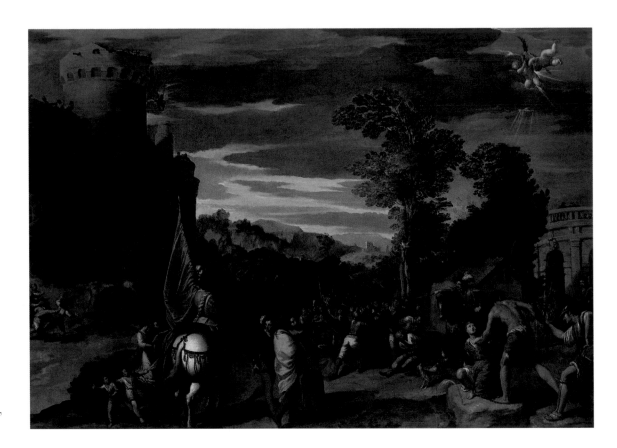

Plate 9. Ippolito Scarsella, called
Lo Scarsellino
(Ferrara 1551-Ferrara 1620),
Martyrdom of St. Venantius of Camerino,
c. 1600, oil on canvas, 56¾ x 79½ in.

the hierarchy of the genres reflects had little to do with the tastes of the public or the demand of collectors. In spite of all that Reynolds might have said against landscape or portraiture, the painters of eighteenth-century England generated more of these subjects than of any other; and the achievements of Gainsborough or Wright of Derby in landscape (see plates 37, 38, and 39), or of Reynolds himself in portraiture (see plate 61), must be counted among the highest productions of British art.

A painter's imagination, or the particularities of his subject, might inspire him to create a work that falls as easily into more than one category, ignoring the academicians' rigid definition of the genres. In this exhibition, for instance, are many pictures that would be as comfortable in one genre as in another. Both Scarsellino's *Martyrdom of St. Venantius of Camerino* (plate 9) and Jean Lemaire's *Mercury and Argus* (plate 10) are history paintings in which landscape dominates the story. Is Bonzi's *Fruit Market* (plate 13) a still life, or is it a scene of everyday life—a genre picture? Is the anecdotal content of Gilpin and Reinagle's *Display on the Return to Dulnon Camp* (plate 40) significant enough to warrant our classifying it as a genre scene or, because we can identify the figures, as a portrait? Veronese's beautiful image of St. Agnes (plate 53) could inspire our devotion, but would we be admiring the saint or the Venetian

woman whose portrait is masked by her attributes? These are examples of the interplay that has always existed between the genres, when imaginative painters have borrowed effects common to one branch of art to adorn or enliven another. The landscapes of Scarsellino and Lemaire, Bonzi's version of the inverted still life, the outdoor Conversation Piece by Gilpin and Reinagle, or the disguised portrait by Veronese—all are classic types that are seen throughout the history of baroque painting.

In other cases, however, the painter deliberately sets out to make a hybrid object, as if to subvert the notion of divisions between the genres. Such is the case with the *Allegory of the Consequences of the Peace of Utrecht* (plate 11) by Paolo de Matteis, a Neapolitan follower of Luca Giordano (1634-1705; see plate 73). In this complex picture, part portrait, part history, the artist shows himself seated on a rock in a landscape overlooking the Bay of Naples and Mount Vesuvius; he is in the act of painting a picture of female figures representing Austria, at left, and Flanders, at right, their hands joined in concord. Around the painter and his canvas is a brilliantly colored storm of activity: in the sky above, Peace and Plenty look down on the scene, while

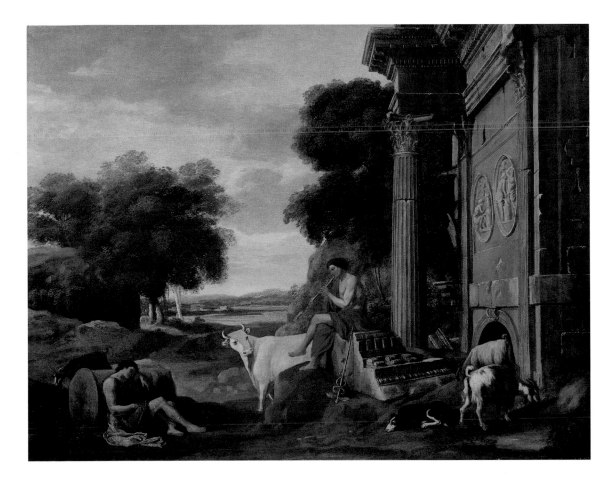

Plate 10. Jean Lemaire (Dammartin 1597/8-Gaillon 1659), *Mercury and Argus*, 1650s, oil on canvas, 29 x 38 in.

Plate 11. Paolo de Matteis
(Cilento 1662-Naples 1728),
*Allegory of the Consequences of
the Peace of Utrecht*, after 1714,
oil on canvas, 30 x 40 in.

Faith, Hope, and Charity are enthroned in a glowing light. An angel with an olive branch, a symbol of peace, drives away Mars, the God of War, at right.

By inserting in the allegory a willfully informal image of himself dressed in work clothes, and by insisting on his self portrait as the most "real" element in the painting, Matteis confounds the hierarchy of the genres. This is not simply a case of a hidden self portrait in the margin of an imposing baroque allegory: it is a playfully subversive conception, "a vulgar idea," as Matteis' biographer wrote, one for which the painter was criticized at the time.[12] The concept was daring because the academic notion of decorum mandated that the painting of history—even contemporary history—should remain inviolate to preserve the hierarchy of the genres. With his ironic gesture, Matteis flouts the hierarchy, but the very success of his image depends on the viewer's awareness of the traditional scale of values.

In the past decade, artists and art historians, as well as the viewing public, have expressed renewed interest in the subject matter of paintings, and they have become more aware of the ways in which the formal qualities of a work of art may be determined by its meaning. The visitor to this exhibition and the reader of this book will move by stages from the voluptuous display of still life to the high-minded realms of history painting. With its focus on the subjects of art as they were established in the baroque period, this exhibition provides an occasion for the consideration of content as well as form.

NOTES

[1] Maurice Denis, "Définition du neo-traditionnisme," *Art et critique* (August 1890), quoted in Linda Nochlin, *Impressionism and Post-Impressionism 1874-1904* (Englewood Cliffs, New Jersey: Prentice-Hall, 1966), p. 187.
[2] Samuel van Hoogstraten, *Introduction to the Elevated School of the Art of Painting*, 1678, quoted in BLANKERT, "General Introduction," p. 18.
[3] Leon Battista Alberti, as quoted by LEE, p. 211.
[4] For Paul Bril, see PIGNATTI, pp. 138-40; also WITTKOWER, p. 43, and JONES. For Campi, see SPIKE 1983, p. 22.
[5] See PEVSNER.
[6] André Félibien, *Conferences de l'academie royale de peinture et de sculpture*, Paris, 1669, collected in FÉLIBIEN, p. 311 (author's translation).

[7] van Hoogstraten, as quoted in BLANKERT, p. 18.
[8] van Hoogstraten, as quoted in BLANKERT, p. 18.
[9] *Discourse III* (1770), REYNOLDS, p. 50.
[10] REYNOLDS, pp. 51-52.
[11] REYNOLDS, p. 52.
[12] B. de Dominici, *Vite dei Pittori, Scultori ed Architetti Napoletani*, vol. 3, Naples, 1742, pp. 538 and 540, quoted in PIGNATTI, p. 162. See also Oreste Ferrari, "Painting in Naples under the Austrian Viceregency (1707-34)," and entry by Nicola Spinosa, in *The Golden Age of Naples: Art and Civilization under the Bourbons 1734-1805*, exh. cat. (Detroit: The Detroit Institute of Arts, 1981), pp. 54, 123-4.

Still Life

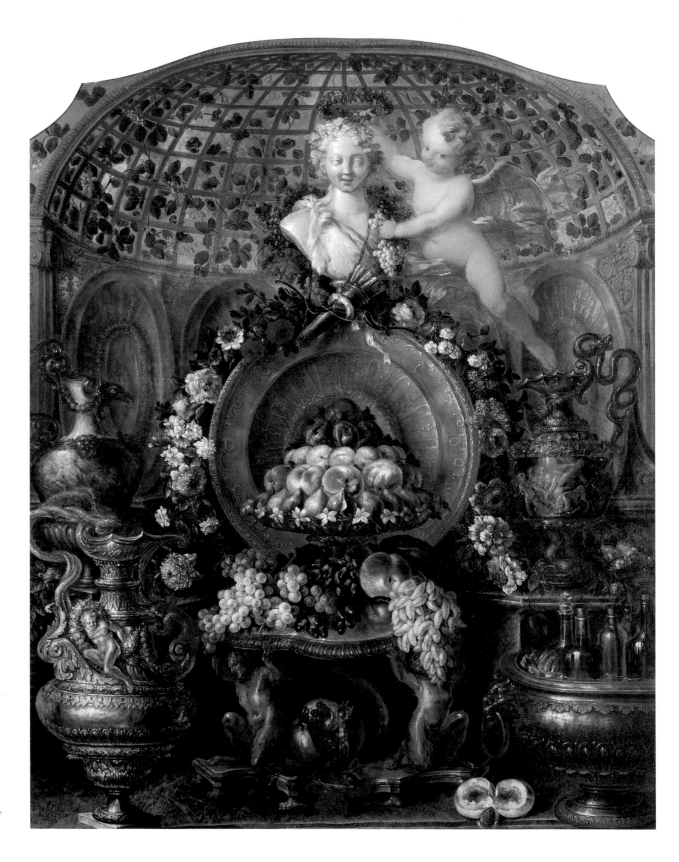

Plate 12. Pierre-Nicolas Huilliot (Paris 1674-Paris 1751), *Still Life with Silver and Gold Vessels, Fruit, and Flowers*, 1718, oil on canvas, 78 x 64 in. framed.

The Silent Poetry of Still Life

GEORGE T. M. SHACKELFORD

Still life paintings are representations of things: of inanimate objects or of living creatures or plants that have been posed as models for the artist. The category of still life is a broad one, encompassing not only the simplest images of household items, foodstuffs, and flowers, but also elaborate allegorical groupings of objects, trophies of game, market displays, and illusions meant to deceive the viewer's eye. The objects represented, whether man-made or natural, living or dead, may be arranged formally to reinforce the image's sense of artifice, or informally to suggest that the painter has come upon the subject by accident.

Still Life: a curious conjunction of opposing words, since that which has life should not, in principle, be still. The modern term *still life*, however, is a direct translation of *stilleven*, a phrase coined in Dutch artistic circles in the mid seventeenth century, where it was used to distinguish works painted from a "motionless model."[1] *Still life* in English and *Stilleben* in German have their origins in this coinage; the Italian *natura morta*, on the other hand, has its roots in the French *nature morte*, or "dead nature," a phrase invented in the eighteenth century which, as Charles Sterling points out, "undoubtedly connotes a shade of contempt."[2]

The origin of the modern still life painting is a matter that has been debated by critics and historians for decades.[3] Certainly such paintings were made long before they were recognized as an autonomous category of art, for independent still life paintings existed in antiquity. Classical authors tell of the success of such painters as Piraikos and the famous Zeuxis, whose paintings of fruit were pecked at by the birds; wall paintings preserved from late antiquity—themselves crowded with illusionistic still life devices—record images of movable still life paintings displayed in ancient villas. Although none of these ancient still life paintings survives, artists of the Renaissance were undoubtedly familiar, through word and image, with a range of still life types from the distant but physically present past, and modern authors agree that the still life as it developed in Italy in the fifteenth century must have been strongly influenced by these classical prototypes.

Painters in northern Europe, on the other hand, are generally given credit for showing the earliest sustained interest in still life as an independent form. In this view, the Northern still life is seen as rising out of the attention paid to accessory details in religious pictures—fruits and flowers placed on a ledge in a painting of the Holy Family, for instance—which often bore an elaborate iconographic significance. Some writers also see the roots of still life in the Northern tradition of floral decorations in

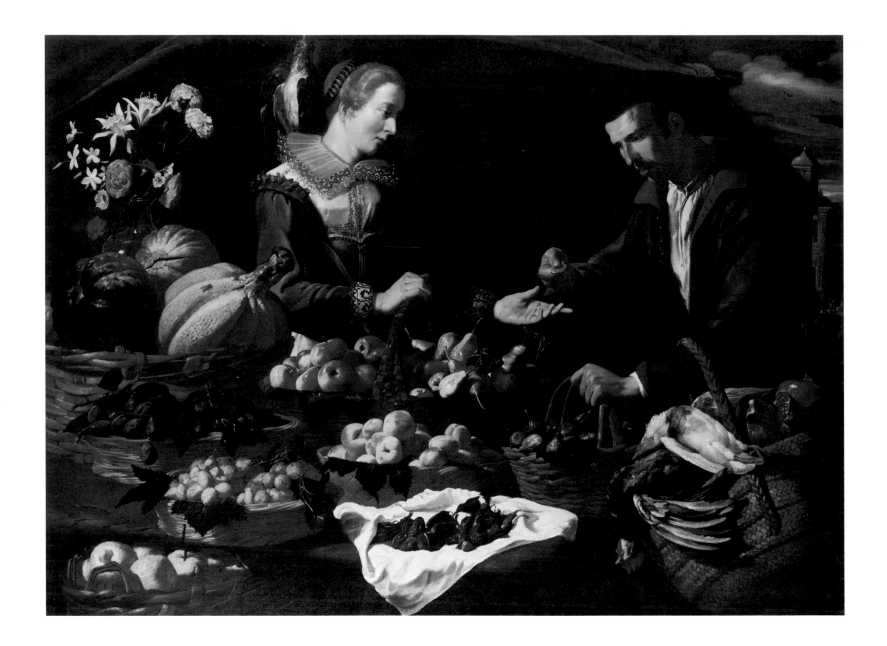

Plate 13. Pietro Paolo Bonzi (Cortona 1576-Rome 1640), *The Fruit Market*, c. 1625-30, oil on canvas, 47½ x 71 in.

illuminated manuscripts of the Gothic and Renaissance periods.[4]

Whether its origins are to be found in northern or southern Europe, it seems clear that the first great body of still life painting took shape only in the Mannerist era of the later sixteenth century, in the form of what we now call the inverted still life. In such a painting, a religious subject is pushed to the background and buried, as it were, behind mounds of foodstuffs arranged in the foreground plane. Thus a painting of the 1560s that ostensibly represented a modern day kitchen, with a serving woman shown preparing fish or meat, might in fact contain a biblical image of *Christ in the*

House of Martha and Mary; or an outdoor market scene might include an illustration of Christ and the woman taken into adultery.[5] At the same time, subordinate still life elements began to play a more important role in the compositions of artists who did not paint still lifes as such: for instance, in the painting of *Christ in the House of Martha, Mary, and Lazarus* by Jacopo and Francesco Bassano in the Blaffer Collection (fig. 1), the kitchen implements and provisions conspicuously arranged in the foreground and at the right of the painting reinforce the realism of the artist's treatment of the figures, situating the Gospel event in a contemporary reality.

The rise of realism in painting in both Italy and the North during the last decades of the sixteenth century—illustrated by these paintings—is probably the single most important factor in the burgeoning of still life painting around 1600. The growing incidence of profane, or at least profoundly secularized, subjects in the 1580s and 1590s exactly coincides with the crystallization of still life as a marginal but accepted form of expression for the serious painter. The early works of Annibale Carracci, such as the *Butcher's Shop* in Fort Worth (fig. 2), suggest the fascination that the depiction of inanimate objects held for the Bolognese realists before the rise of baroque classicism. A decade later, the Roman master Caravaggio (1571/72-1610) painted the famous still life of about 1596, now in the Pinacoteca Ambrosiana of Milan, that is a key work in the development of this tradition, and surprised academics by saying "that it cost him as much effort to make a good painting of flowers as of figures."[6]

Out of this varied but influential artistic milieu rose Pietro Paolo Bonzi, whose *Fruit Market* is exhibited here (plate 13). Born with a hunched back, Bonzi called himself *"Gobbo dei frutti"* ("hunchback of the fruits") and was also nicknamed *"Gobbo dei Carracci,"* because of his ties to followers of the Carracci family.[7] His *Fruit Market*, a work that dates from the early decades of the seventeenth century, is composed along the lines of the Mannerist inverted still life of the later sixteenth century, with its abundance of natural materials piled somewhat randomly in the lower zone of the canvas. Bonzi details baskets of melons, apples, pears, and peaches with strong color and with striking Caravaggesque light, scattering black-purple fruit against a stark white cloth. A bouquet of flowers is placed in a glass jar at the left, and a pair of fowl share a basket with ripe pomegranates at the lower right-hand corner.

In the upper register of the painting, a man is shown paying a woman for fruit he has purchased, but the still life elements dominate the canvas both spatially and coloristically. The fruits do not exist, as they do in the inverted still life of the previous generation, as a tangible earthly counterpoint to a much more important spiritual story taking place in the background. Even though Bonzi includes figures in his composition, he avoids any overt historical or religious meaning, proposing instead a rich-

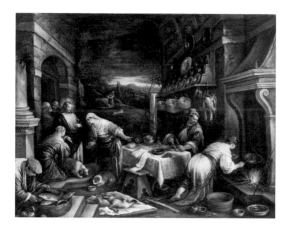

Fig. 1. Jacopo Bassano (Bassano 1510/15 -Venice 1592) and Francesco Bassano (Bassano c. 1549-Venice 1592), *Christ in the House of Martha, Mary, and Lazarus*, c. 1577, oil on canvas, 38¾ x 49¾ in.

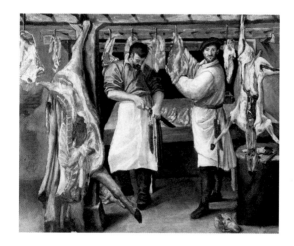

Fig. 2. Annibale Carracci (Bologna 1560-Rome 1609), *The Butcher's Shop*, c. 1582, oil on canvas, 23½ x 28 in., the Kimbell Art Museum, Fort Worth.

Plate 14. Pieter Claesz. (Burg-Steinfurt (Germany) c. 1597- Haarlem 1661), *Still Life with Meat*, c. 1650, oil on panel, 36⅞ x 55 in.

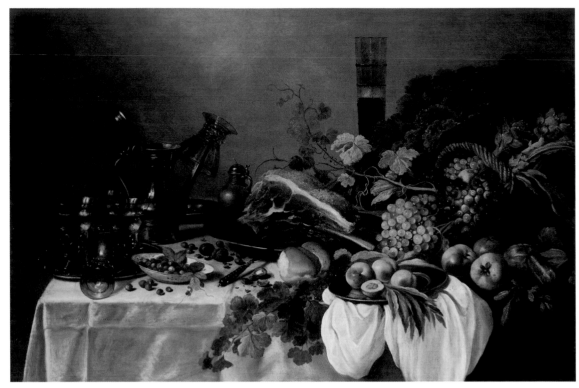

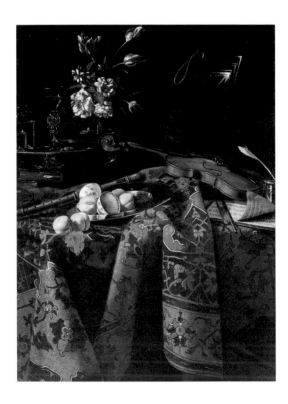

Fig. 3. Cristofaro Monari (Reggio c.1667-Pisa 1720) *Still Life with Musical Instruments*, c. 1710-15, oil on canvas, 53¾ x 39 in., the Museum of Fine Arts, Houston, the Samuel H. Kress Collection, 61.60.

ly materialistic display of natural objects. Although the man's gesture of payment might carry a secondary erotic meaning, the figures are rightly seen as secondary accessories to the magnificent market still life in the foreground: they provide an everyday context for this grouping of the fruits of nature.

It is possible, however, that at least some of Bonzi's contemporaries would have continued to appreciate the market scene in other terms. The famous still life by Caravaggio cited above was owned, and probably commissioned by, Cardinal Federico Borromeo, a man who was widely known for the pleasure he took in art that was not patently sacred in subject. Borromeo owned a remarkable collection of landscapes and still lifes, almost all by Flemish artists active in Rome, as well as many paintings of religious themes. Still, the Cardinal seems to have interpreted even the most lavish and voluptuous of his flower paintings in Christian terms, seeing the beauties of nature as evidence of God's goodness.[8]

The tension between the material, sensual aspects of a still life painting and its spiritual or moral dimension lies at the heart of the lowly status of the genre in the hierarchy of academic practice. Borromeo's appreciation of godliness in creation notwithstanding, most seventeenth-century theorists and critics saw the open celebration of the surfaces of things—soulless things, that is—as unworthy of the highest

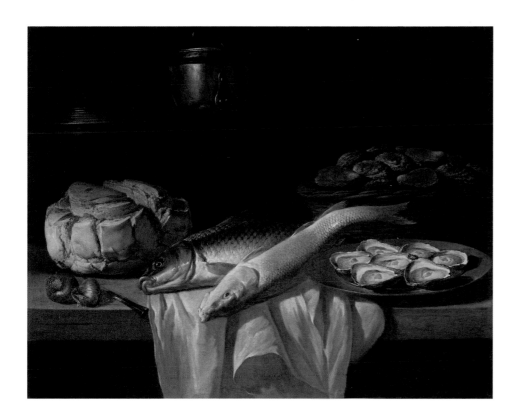

Plate 15. Pierre van Boucle (Antwerp?
c. 1600-Paris 1673), *Still Life with Carp
and Pike*, 1652, oil on canvas,
31½ x 39¾ in.

skills of the painter of intelligence. Still lifes, in the view of academics, were too exclusively concerned with sensory phenomena, and incapable, in fact, of conveying grand themes and emotions, although the religious philosophy that underscored much criticism of works of art made it possible to interpret almost any image in moral terms. It was possible for a still life to have explicit moral resonance if it represented the *vanitas* theme, illustrating the idea of the fragility of human life. By placing an hourglass, a beribboned pocket watch, or a human skull amidst a luxurious arrangement of natural or artificial objects, the painter could remind the viewer of the transience of human existence.

Nonetheless, the majority of baroque still lifes appeal frankly and unabashedly to the senses. Cristoforo Monari's tabletop arrangement in the Museum of Fine Arts, Houston, for example (fig. 3), is an allegory of sensory perception: a mirror represents sight; musical instruments suggest hearing; flowers, the sense of smell; a glass of wine refers to taste; and the raised brushwork of the Turkey carpet invites the possessor to touch the very surface of the painting. But great painters, theoreticians of the period argued, should avoid appealing to the senses alone, and devote themselves to lofty themes, to subjects with *istorie*. The artist who specialized in fruits or flowers in baroque Italy was, by this reasoning, relegated to a lower station in the ranks of his

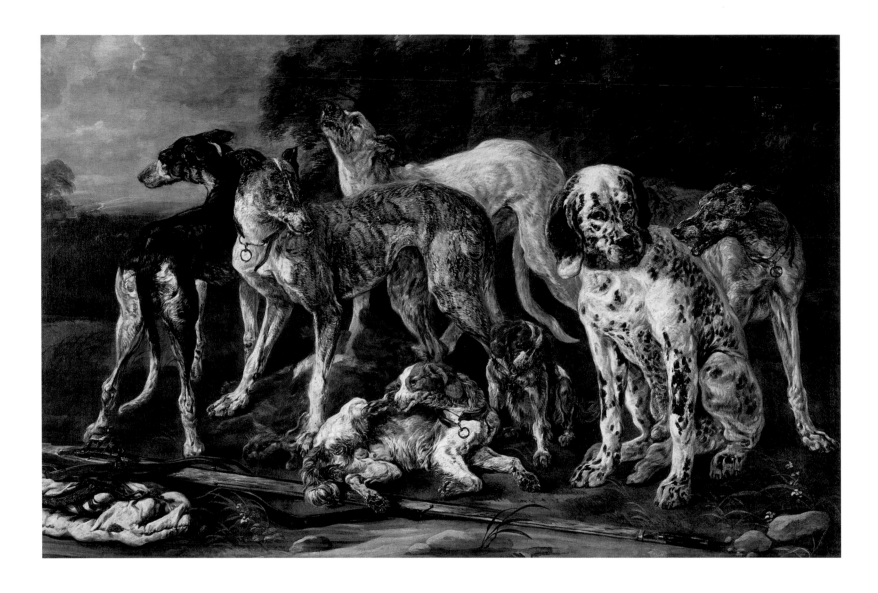

Plate 16. Jan Fyt (Antwerp 1611-
Antwerp 1661), *Hounds Resting from
the Chase*, c. 1640s, oil on canvas,
49 x 74 in.

fellow painters—no matter that his skill, as in Bonzi's or Monari's case, enabled him to paint brilliant formal compositions, to observe and to translate beautiful effects of color and of light.

In the Netherlands, the most avowedly materialistic society in seventeenth-century Europe, the painter who celebrated the abundance and beauty of nature or the wealth of man and his table fared rather better.[9] In the northern Netherlands, a tradition of tabletop still lifes evolved, called by such shorthand terms as "banquet" or "breakfast," depending on the objects and foodstuffs represented. Pieter Claesz., a Haarlem artist whose prolific career spanned from the 1620s to the 1660s, together with the painters Willem Claesz. Heda (1594-1670) and Jan Jansz. den Uyl (1595/96-1640), helped to popularize a subcategory of these "banquets," painting in

a close range of grays and earth tones highlighted with select passages of color.[10]

The *Still Life with Meat* by Claesz. in the Blaffer Collection (plate 14), a large panel dated 1650, shows a tabletop with a display of assorted fruits, vegetables, and nuts, together with meat, bread, and drinking vessels. Although such still lifes customarily contain allusions to such themes as the brevity of life and wealth, they were appreciated in their own time, as now, as much for the skill of the painter in handling purely surface effects of texture and reflection. Here Claesz. records the varied sheen of reflective metal, translucent glassware, and the opaque skin of fruit; similarly, he contrasts the softness of a linen cloth with the solidity of a pewter charger or the brittleness of an overturned blown glass beaker. This type

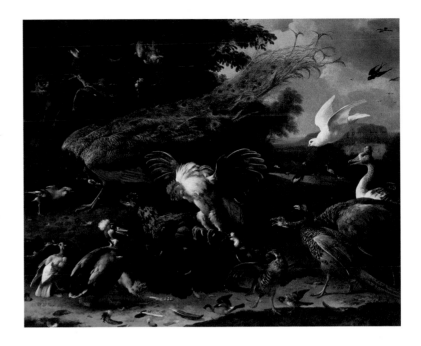

Plate 17. Melchior d'Hondecoeter (Utrecht 1636-Amsterdam 1695), *The Crow Exposed*, c. 1680(?), oil on canvas, 67 x 83¼ in.

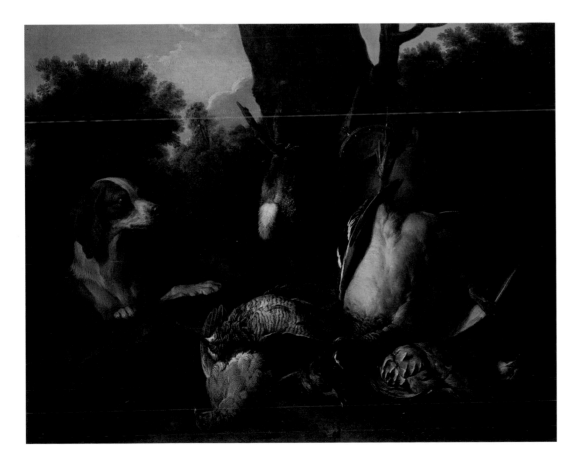

Plate 18. Alexandre-François Desportes (Champigneulle 1661-Paris 1743), *Still Life with Dog and Game*, 1710, oil on canvas, 32¼ x 40⅝ in.

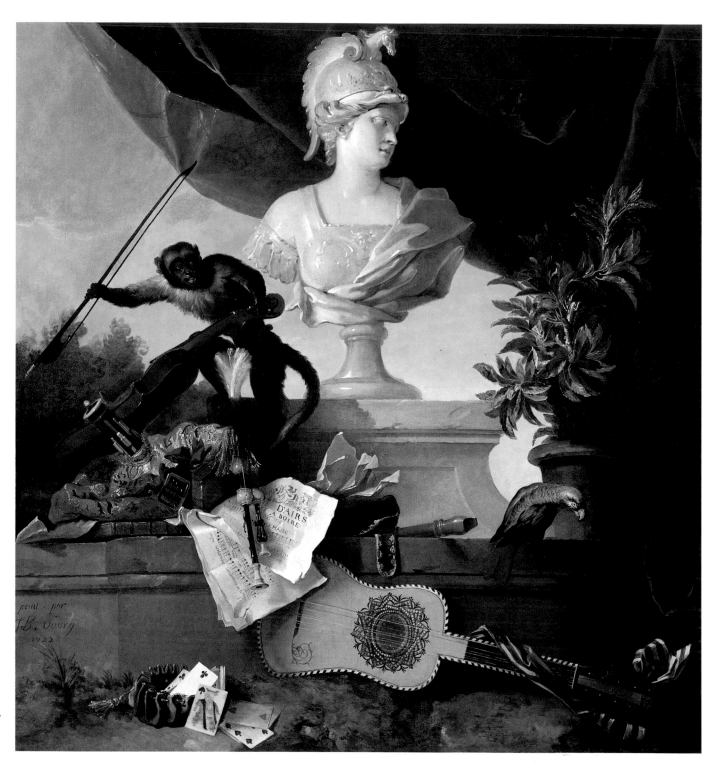

Plate 19. Jean-Baptiste Oudry (Paris 1686-Beauvais 1755), *Allegory of Europe*, 1722, oil on canvas, 63¾ x 59¾ in.

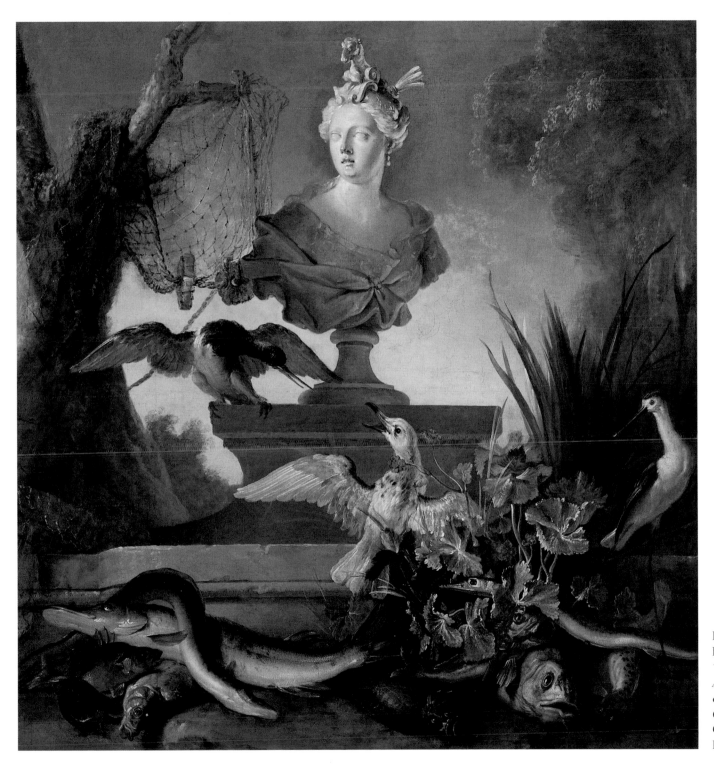

Plate 20. Jean-
Baptiste Oudry (Paris
1686-Beauvais 1755),
Allegory of Asia,
c. 1722, oil on canvas,
63¾ x 59¾ in.,
Collection of
E. Joseph Hudson, Jr.

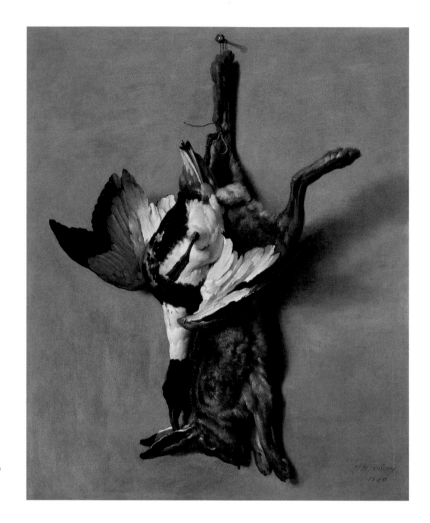

Plate 21. Jean-Baptiste Oudry (Paris 1686-Beauvais 1755), *Still Life with Hare and Sheldrake*, 1740, oil on canvas, 34⅝ x 28 in., Collection of E. Joseph Hudson, Jr.

of still life, furthermore, found affinities across Europe: Pierre van Boucle, a Flemish artist active in Paris from the 1630s until his death in 1673, likewise employed a limited color range, and an atmosphere of stillness and calm, as is shown in his beautiful *Still Life with Carp and Pike* of 1652 (plate 15).[11]

Simultaneously, however, artists such as Frans Snyders (1579-1657) and Jan Fyt, working in Flanders in the spirit of Peter Paul Rubens, or the Dutch-born Jan Davidz. de Heem (1606-1683/84), active in Antwerp, lavished their efforts on dynamically composed and richly textural still lifes that gloried in abundance for its own sake. Snyders and Fyt, above all, delighted in the aftermath of the courtly hunt: they painted elaborate buffets on which are displayed great birds or beasts, or game strung up against an architectural background. In the Blaffer Collection is Fyt's *Hounds Resting from the Chase* (plate 16), a tour-de-force in the depiction of lithe musculature and bristling fur. The painting is not strictly a still life: standing beside

the trophy of dead hare and rifle, the animals flex and scratch somewhat restlessly. Although the artist was able to stretch the boundaries of the genre to include this portrait of a pack of hounds, Fyt's painting would have been ranked with one of his more conventional game pieces in an academic hierarchy of types. In fact, all such groups of animal or fowl—such as Melchior d'Hondecoeter's *The Crow Exposed* (plate 17), an illustration of an Aesop fable—were ranked with still life in the eyes of academics.

Seventeenth-century Dutch and Flemish painters, in fact, established the still life formulas with which future generations, and particularly eighteenth-century French artists, were to work: tabletops and banquets, buffets, kitchens, game pieces in nature or indoors, or richly varied floral bouquets. Thus François Desportes adopts the formula of Snyders or Fyt in his *Still Life with Dog and Game* (plate 18), and Pierre-Nicolas Huilliot merges the architectural format of their works with the colorism of de Heem in his *Still Life with Silver and Gold Vessels, Fruit, and Flowers* of 1718 (plate 12), a work intended in its grand scale and in its subject matter for the decoration of a dining room.

The influence of the Netherlands can also be seen in the work of Jean-Baptiste Oudry, represented in this exhibition by three works, who after Jean-Baptiste Siméon Chardin is the most inventive and sensitive still life painter of the eighteenth century in France. Like Chardin, Oudry was adept at many kinds of painting; in his early career he painted as many as one hundred portraits, and we know of history paintings and landscapes, now missing, from copies in his notebooks and from independent drawings.[12] Oudry's reception piece for the academy in 1719 was an allegory of abundance (Versailles, Musée national du château), showing a female figure surrounded by the riches of the earth, including fruits, vegetables, flowers, grains, and the beasts of the field. Between 1719 and 1721, he painted for his own pleasure a series of allegorical still lifes representing the four elements: air, water, fire, and earth.[13] The components of two of these allegories are repeated with variants in the paintings of 1722 exhibited here, the *Allegory of Europe* (plate 19), also an allegory of air, and the *Allegory of Asia* (plate 20), which similarly contains an allegory of water. Here the continents are represented by carved marble busts placed on plinths at the center of the composition; the elements, on the other hand, are illustrated by still lifes of natural and man-made objects. In the Blaffer Collection *Allegory of Europe*, for example, the element of air is suggested by the bird and by the monkey that leaps through the air, as well as by the musical score of "an air," or *aria*. Similarly, in the *Allegory of Asia*, a watery still life of fish and aquatic birds fills the foreground.

Large in scale and ample in spirit, these works express the transformation of the grand baroque style in the early years of the reign of Louis XV, for whom Oudry was later to work. Together with paintings that represented the continents of Africa

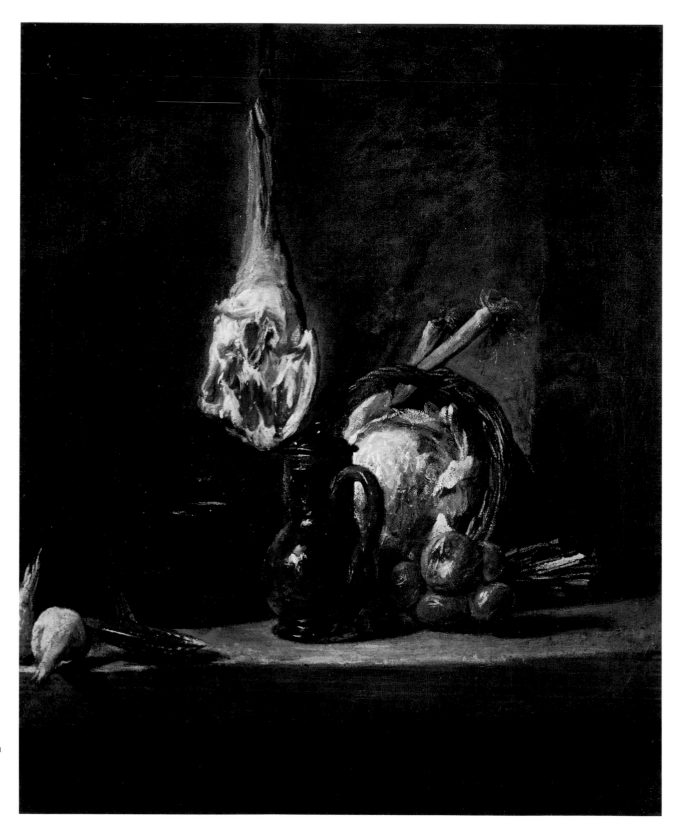

Plate 22. Jean-Baptiste Siméon Chardin (Paris 1699-Paris 1779), *Still Life with Joint of Lamb*, 1730, oil on canvas, 15¾ x 12¹³⁄₁₆ in.

and America, and the elements of earth and fire, these sensuously painted works would have formed an impressive decorative ensemble in the early Rococo manner.

Altogether different in character, Oudry's *Still Life with Hare and Sheldrake* from nearly twenty years later (plate 21) is as unpretentious and melancholy as the *Allegories* are resplendent and exuberant. Using a close range of browns and whites against an off-white background, Oudry captures the most delicate contrasts: the texture of fur is shown against that of feather; the vertical axis of the hanging prey is broken by the pathetically drooping wings of the bird and the unbound leg of the hare; the chalky gray of the wall is the background for a single glistening ruby drop of blood. In spite of its exploration of surfaces, however, this painting of a humble subject achieves the most profound end, for it is filled with poetry and pathos. It is rightly a vision of *nature morte*, a reminder of death in the midst of life.

The painting's quiet simplicity comes closest to the work of Chardin, certainly one of the greatest still life painters in the history of art. In the Blaffer Collection *Still Life with Joint of Lamb* (plate 22), we see Chardin's extraordinary ability to create an intensely private world with a simply defined space and a few objects: a hanging joint, a crockery jug, some vegetables to add a hint of color. This type of painting, intimate and profoundly personal, attests to the continuing power of still life to inspire the artist and gently waken the emotions of the viewer. The objects in still life painting are motionless and silent, but they often speak about the most personal meditations of the painter. Still life, the least heroic of the genres, when in the hands of the greatest painters is the most poetic.

NOTES

[1] See STERLING, p. 43, for a discussion of the origins of the modern usage *still life*.

[2] STERLING, p. 43.

[3] See, for example, FRIEDLÄNDER, pp. 277-78; STERLING, pp. 5-6; BERGSTROM, pp. 4-41.

[4] See above all BERGSTROM, historical introduction.

[5] See Vincenzo Campi's *Christ in the House of Martha and Mary*, Galleria Estense, Modena, in JORDAN, fig. 4; see also Pieter Aertsen, *Christ and the Adultress*, Städelsches Kunstinstitut, Frankfurt, in SCHNEIDER, p. 26.

[6] Caravaggio was quoted by Vincenzo Giustiniani; see SPIKE 1983, p. 14.

[7] See SALERNO, pp. 92-97, and Alberto Cottino, "La Natura morta caravaggesca a Roma," in PIROVANO, pp. 678-81.

[8] See Pamela M. Jones, "Federico Borromeo as a Patron of Landscapes and Still Lifes: Christian Optimism in Italy ca. 1600," *Art Bulletin*, vol. 70 (June, 1988), pp. 261-272.

[9] For the most recent discussion of this sumptuous still life tradition, see SEGAL.

[10] See VROOM for a full discussion of the monochrome still life; see also SEGAL, pp. 121-40.

[11] See Jacques Foucart, "Un peintre flamand à Paris: Pieter van Boucle," in CHATELET & REYNAUD, pp. 237-56, no. 13; see also FARÉ, vol. 11, fig. 89.

[12] See OPPERMAN for a summary of Oudry's career.

[13] The paintings, at the Royal Castle, Stockholm, on loan from the Nationalmuseum, are reproduced in OPPERMAN, p. 45.

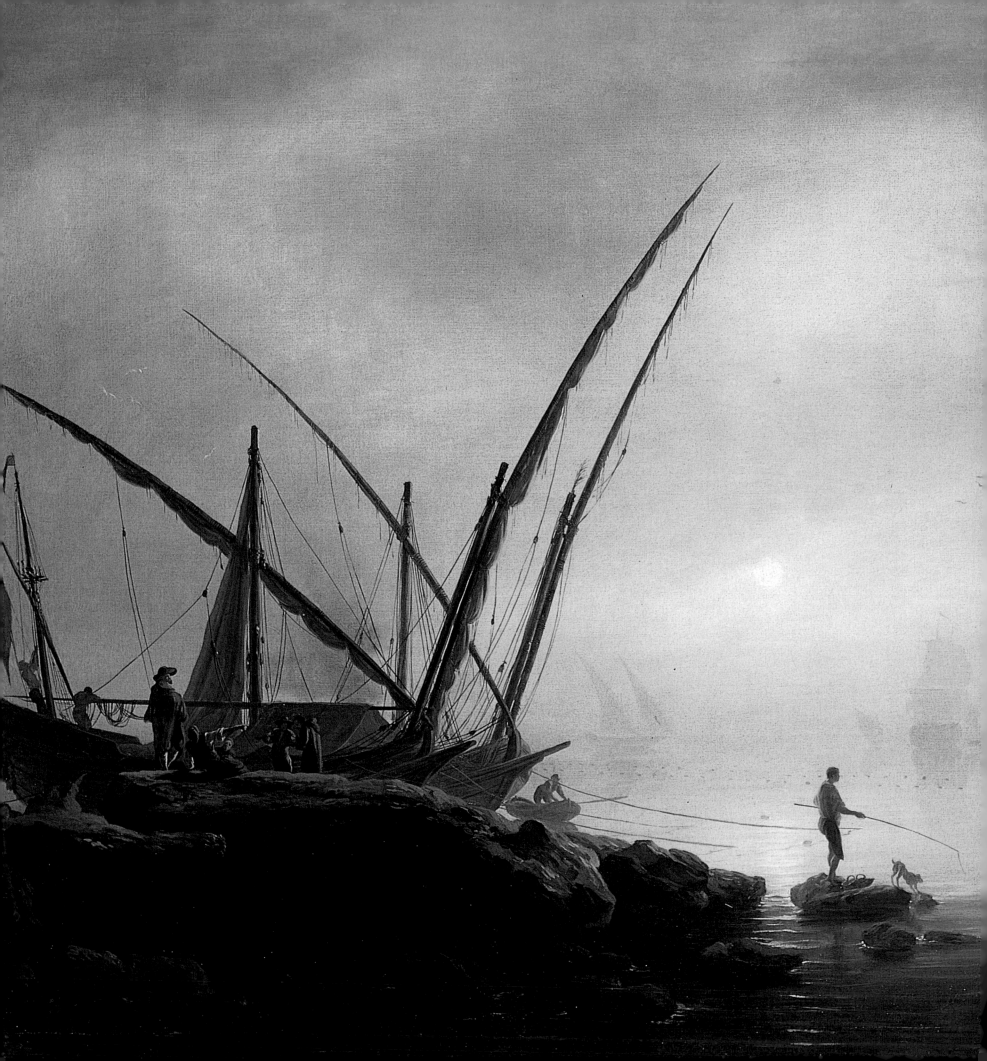

Landscape

34

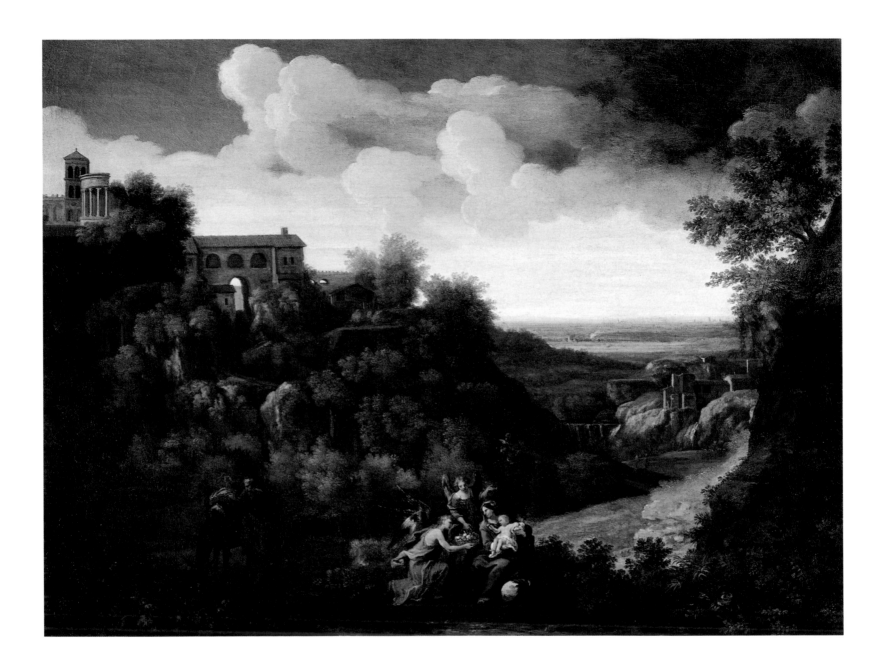

Plate 23. Gaspard Dughet, also called
Gaspard Poussin (Rome 1615-Rome
1675), *The Rest on the Flight into Egypt*,
1653-57, oil on canvas, 28½ x 38⅝ in.

Baroque Landscape Painting: The Domain of Light

KATHERINE T. BROWN

Throughout the Renaissance, some artists had found the realistic depiction of nature no less challenging and interesting to paint than the human figure. First used exclusively as a background for other subjects, small bits of landscape were expanded in depth and breadth until the background competed for attention with the ostensible subject. Several motives stimulated this development: a desire to celebrate the beauty of divine creation, a drive to enlarge the stage for human action, and, above all, the artist's fascination with representing every aspect of the visible world. By the early seventeenth century, landscape was fully accepted as a legitimate subject for painting, and artists began a wide-ranging exploration of the possibilities and meanings inherent in landscape painting. Landscape is a painter's, not a sculptor's, subject.

Basic problems in representing deep space had already been solved by using a combination of atmospheric and linear perspective. Atmospheric perspective creates an illusion of distance through changes in color and definition: as land forms approach the horizon, they turn blue and detail is lost in a light haze. Linear perspective, though more applicable to architecture than to landscape, uses the position of the viewer to determine correctly diminishing scale. Baroque artists continued to produce their actual paintings in the studio, but many of them adopted the practice of sketching constantly from nature to record effects of light or to make detailed renderings of buildings, trees, rocks, and clouds. Such drawings became an artist's stock-in-trade, used to develop any number of studio paintings.

Though ranked below history painting, landscape paintings attracted the buying public. They were generally produced not on commission, but for an open market, a phenomenon that first became common at this time. Many artists devoted themselves exclusively to landscape painting and built a reputation for a specialty such as Italian scenes, city views, or marine subjects.

Landscapes of the baroque period are not paintings of wilderness. This is landscape inhabited by man, supporting human life and human labor, the stage for human history, and the setting for man's experience of the infinite and the divine. At the same time, a major shift occurs in the artist's approach to landscape. Detail is subordinated to light as the experience of landscape changes from an exploration of the variety in nature to a journey through light-filled space.

Baroque painting in all categories tends to divide between images of ideal worlds—Christian or pagan—and images of the contemporary scene. Many years ago

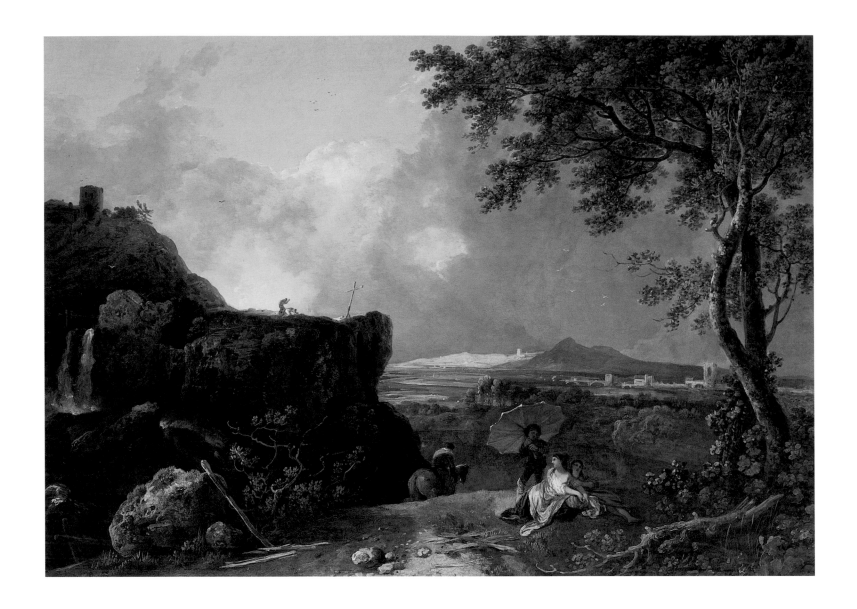

Plate 24. Richard Wilson (Penegoes, Wales 1713/14-Mold, Wales 1782), *The White Monk*, c. 1760-65, oil on canvas, 36 x 51¼ in.

Kenneth Clark, in a survey of landscape in Western painting, drew a distinction between the ideal landscape and the landscape of fact.[1] The ideal landscape, which in Baroque painting is also called the classical landscape, belonged to Italy. The landscape of fact developed in the North, specifically in the work of Dutch artists painting their own coast and countryside. Both forms of landscape were taken up by artists from other countries, but the distinction between them remains clear.

The ideal landscape is a realistic but perfected landscape, based on a study of nature. Inspired by the Roman Campagna and the environs of the Bay of Naples, it is haunted by memories of classical poetry. Here beside the streams and in the wooded hills of Arcadia, men and women live in harmony with nature.

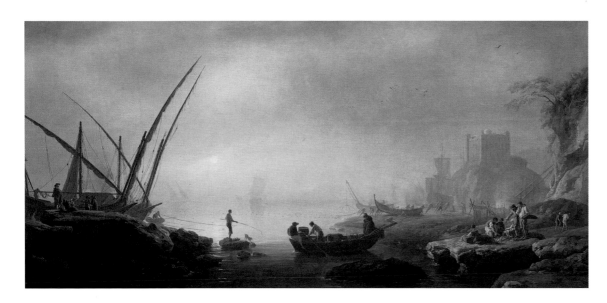

Plate 25. Charles-François Lacroix de Marseille (Paris, Avignon, or Marseilles c.1720-Berlin 1782), *An Italian Port Scene*, 1770, oil on canvas, 35½ x 72 in.

Sources for the baroque ideal landscape have been traced to sixteenth-century Venetian painting and to the landscapes of Paul Bril (1554-1626) and other northern artists in Italy before and after the turn of the century. Its form was clearly established early in the seventeenth century by Bolognese artists who had come south, attracted by the patronage of the papal court in Rome. To Rome also came two Frenchmen, Nicolas Poussin (1594-1665) and Claude Lorrain (fig. 4), whose paintings became models for the construction of such a landscape. Poussin emphasized the ordering of the landscape with a clear stepping back from foreground to distance. Strategically placed buildings stabilize the undulating forms of nature with the horizontals and verticals of architecture. In Claude's landscapes, on the other hand, a continuous recession into light takes precedence over the spacing and solidity of the forms, so that every element in the painting serves primarily to frame or screen that recession.

Gaspard Dughet, also known as Gaspard Poussin, was born in Rome of French parentage and studied under Poussin, who later married Dughet's sister. In Dughet's painting *The Rest on the Flight into Egypt* (plate 23), a valley curves back into deep space, framed on either side by wooded bluffs and architecture. To anyone familiar with the environs of Rome, the ruined temple on the left would have recalled the temple above the river at Tivoli. The viewer looks past the figures of the Holy Family in the foreground to the sweeping space and light-filled distance.

Over a century later the English painter Richard Wilson, who admired Dughet, repeated the earlier artist's composition almost exactly in *The White Monk* (plate 24): the foreground figures and, behind them, the valley curving between wooded hills. Backed by a radiant sky, the two monks appear to be kneeling not only to the cross,

Fig. 4. Claude Gellé, called Le Lorrain (Champagne 1600-Rome 1682), *Pastoral Landscape with a Rock Arch and a River*, c. 1630, oil on canvas, 37⅞ x 52⅞ in., the Museum of Fine Arts, Houston, museum purchase with funds provided by the Agnes Cullen Arnold Endowment Fund, 73.172.

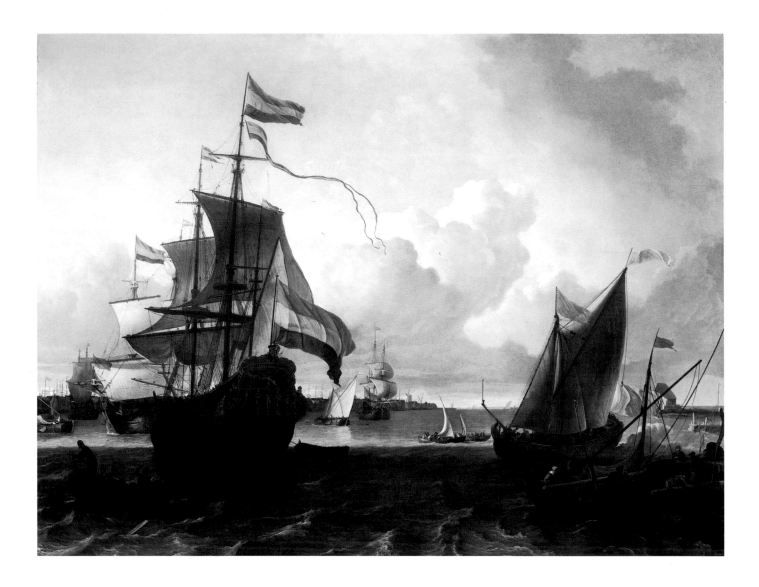

Plate 26. Ludolf Bakhuyzen (Emden, 1631-Amsterdam 1708), *The Dutch Man-of-War "De Gouden Leeuw" on the River Y near Amsterdam*, 1674, oil on canvas, 48¼ x 61½ in.

but also to a divinity suffused throughout the natural world. The continuing influence of Claude in the eighteenth century is apparent in *An Italian Port Scene* by Charles-François Lacroix de Marseille (plate 25). Boats and figures in the foreground are obscured in shadow, so that nothing will slow the viewer's passage into a pool of luminous space.

While Italy was the locus of the ideal landscape, the art of northern Europe, and particularly that of the Netherlands, initiated a landscape tradition grounded in the specific topography of the land. The Dutch had every right to be proud of their country. In the second half of the sixteenth century, they had won their independence from Spain, had rejected Catholicism and papal supremacy, and had beaten back the ocean to extend their territory by a system of dikes and drainage. In the wake of this

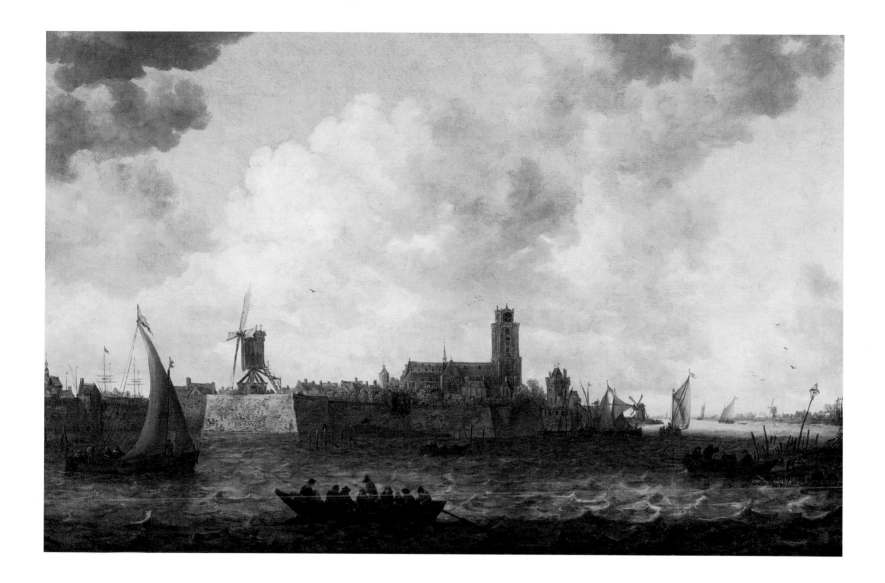

struggle, the northern Netherlands became the most prosperous country in Europe and a leading maritime power on the high seas—a fact celebrated by the painter Ludolf Bakhuyzen (plate 26). Dutch painting of the seventeenth century, in its images of Dutch faces, Dutch life, Dutch homes, Dutch towns, and Dutch landscape, is a reflection of that pride and prosperity.

The Dutch were the first European artists north of the Alps to see in their own flat coastal land and the immensity of their cloud-filled sky dramatic subjects for landscape painting. To describe these landscapes as realistic is to say little more than that they appear to be presented in a straightforward, recognizable fashion as the eye might see them. But the "landscape of fact" is, in fact, an impossibility. No painter can directly transpose the three-dimensional, light-filled world that his eye sees onto a

Plate 27. Jan van Goyen (Leiden 1596-The Hague 1656), *View of Dordrecht from the Northeast*, 1647, oil on canvas, 37¼ x 57½ in.

Plate 28. Jacob van Ruisdael (Haarlem
1628/9-Amsterdam? 1682), *Landscape with
Cornfields*, 1670s, oil on canvas, 21¾ x 24⅞ in.

two-dimensional, opaque surface of limited dimensions. What two generations of Dutch artists did achieve during the first half of the seventeenth century was to identify in their own landscape certain paintable relationships that could stand for the totality of what the artist wished to represent.

The basic relationship in all landscape painting is that of the earth to the sky, which is indicated by the horizon line and by the mountains, trees, or buildings that project into the sky. Earth and sky remain distinct, but in painting they must be unified, because our experience of landscape is not of one or the other but of both. To suggest the immensity of the sky as well as the flatness of the land, Dutch artists dropped the horizon line from above the midpoint to the lower third or lower quarter of the painting.[2] Like mirrors, the land and sea reflect sunshine and the shadows of clouds. To further unify the scene and to convey an effect of atmospheric haze, certain artists, known as tonal painters, restricted their colors to a range of warm and cool grays.

Jan van Goyen's *View of Dordrecht from the Northeast* of 1647 (plate 27) is an example of tonal painting that is almost monochromatic. There is no diagonal recession into space. Beyond a shadowed foreground, the painting moves into depth through alternating bands of light and shadow with both sides of the scene left open. The horizon is set low. Using minimal means, the artist has brilliantly suggested choppy water and rain-filled clouds, as well as the busy activity of the boats in the river harbor of Dordrecht.

Jacob van Ruisdael, who belongs to the next generation of Dutch landscape painters, worked with a greater range of color and a heavier application of paint. In his *Landscape with Cornfields* (plate 28), the rolling terrain has real solidity. To the right, the viewer looks up at the sunlit dune and the trees projected against the sky where their forms are repeated in the masses of cloud. To the left, a stream moves toward the flat patch of cornfield. The scene presents itself as neither more important nor less important than any other piece of Dutch countryside. The viewer is encouraged to climb the dune and then explore the space freely on his own.

Aelbert Cuyp's (1620-1691) *Horsemen before Ubbergen Castle* of the 1650s (plate 29) should properly be described as figures in a landscape, but Cuyp's experience as a landscape painter is clearly evident in this quiet, spacious painting. Beyond the foreground shadow, the scene is caught in a pool of afternoon light. The only activity is the network of opposing directions set up by the position of the horses, the gazes of the riders, the castle, the slanting light, and the wind-driven clouds: inward, outward, and diagonally from left to right and right to left. Anchoring these opposing directions, the rider in red sits firmly on his horse in the very center of the painting. To the left, in what appears to be a dry moat or trench, a shadowed figure stands in the

Plate 29. Aelbert Cuyp (Dordrecht 1620-
Dordrecht 1691), *Horsemen before
Ubbergen Castle*, c. 1650s, oil on panel,
23 x 29 in.

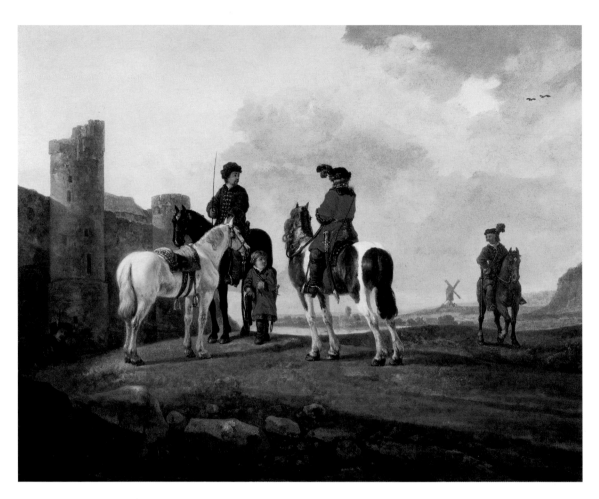

Fig. 5. Giovanni Paolo Panini (Piacenza
1691-Rome 1765), *Imaginary Landscape
with Monuments of Ancient Rome*, 1737,
oil on canvas, 38¹⁵⁄₁₆ x 54⅛ in.,
the Museum of Fine Arts, Houston,
The Samuel H. Kress Collection, 61.62.

role of an observer. There is no record that Aelbert Cuyp ever traveled to Italy,[3] but he would have had an opportunity to study classical or Italian landscapes in the Netherlands either from engraved copies or from originals. Here, as in other paintings, he has introduced the golden light of Italy into a scene of Dutch horsemen.

Italy—or the *idea* of Italy—continued to have a hold on the European mind in the eighteenth century. A knowledge of classical literature and history were regarded as the foundation of an education. For travelers on the Grand Tour, the English in particular, Italy was the high point of their journey. One traveled to Italy, as Samuel Johnson said, to see those things which every educated person should see. To capitalize on the desire of these well-to-do travelers to carry home a souvenir of their experience, a group of painters in Rome and Venice produced views of the famous monuments and sights that every tourist would encounter. Such artists became known as view painters. A few attained such a reputation among their foreign patrons that they were invited to practice their skills abroad.

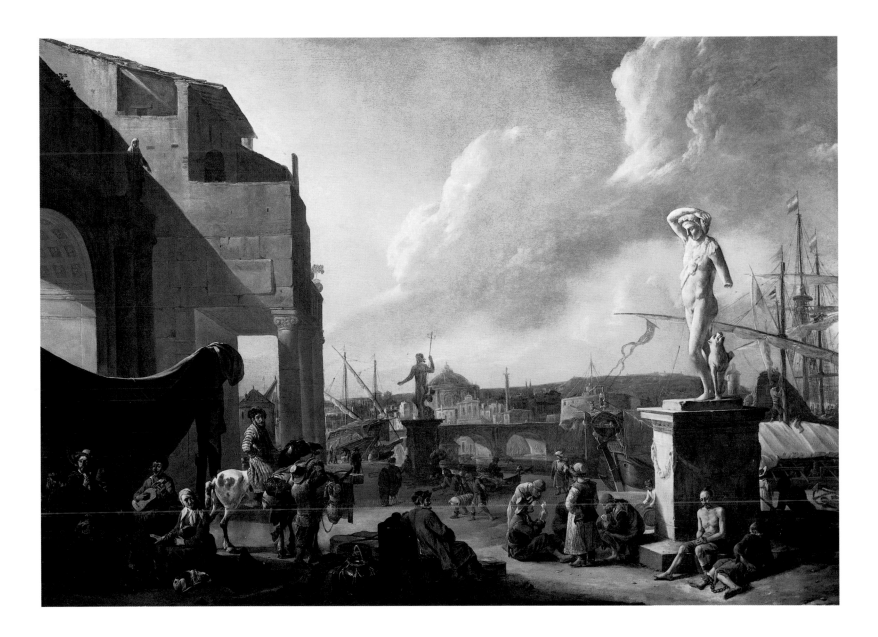

The leading view painter in Rome in the second quarter of the eighteenth century was Giovanni Paolo Panini (fig. 5). Panini's paintings are based on careful drawings of the most familiar monuments of antiquity and surviving examples of classical sculpture, which he then regrouped in a variety of wholly fictitious combinations. Their charm lies in their effects of light and in this combination of convincing realism and whimsical invention. Ruins known to lie in the center of the city may be set down in a half-deserted countryside. Such an imaginary view is known as a *capriccio*. The *Capriccio View of Rome with the Castel Sant' Angelo* of 1655 by the German artist Johannes Lingelbach (plate 30) prefigures Panini's inventions by almost a century.

Plate 30. Johannes Lingelbach (Frankfurt-am-Main 1622-Amsterdam 1674), *A Capriccio View of Rome with the Castel Sant' Angelo*, 1655, oil on canvas, 33¼ x 46 in.

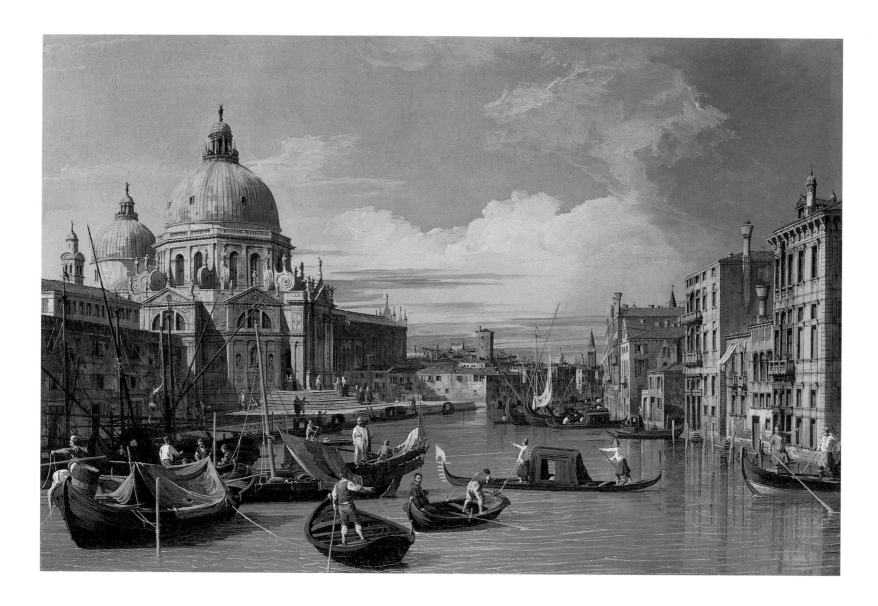

Plate 31. Antonio Canal, called Canaletto
(Venice 1697-Venice 1768), *Grand
Canal, Entrance Looking West*, c. 1730,
oil on canvas, 19½ x 29 in., the Museum
of Fine Arts, Houston, the Robert Lee
Blaffer Memorial Collection, gift of Sarah
Campbell Blaffer, 56.2.

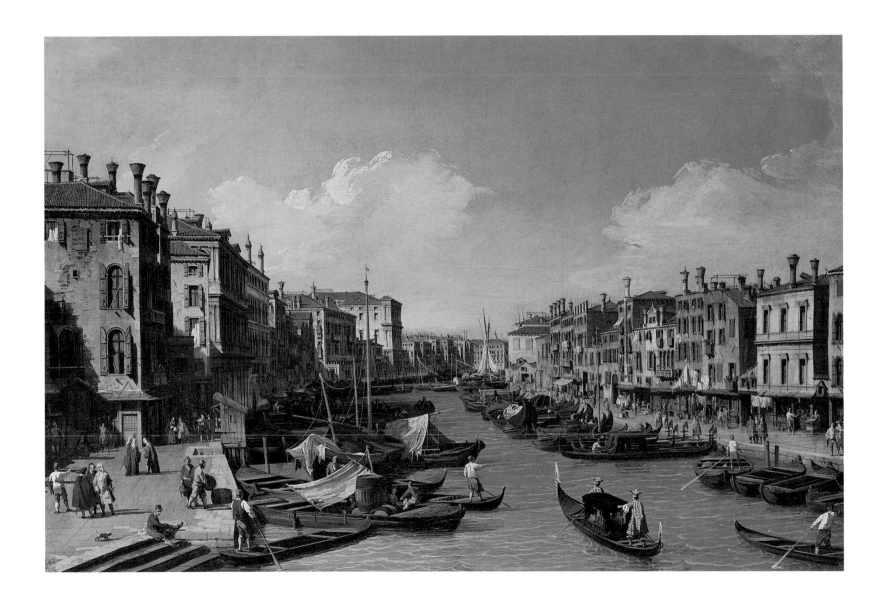

Plate 32. Antonio Canal, called Canaletto
(Venice 1697-Venice 1768), *Grand
Canal, Looking Southwest from near
Rialto Bridge*, c. 1730, oil on canvas,
19⅞ x 28¾ in., the Museum of Fine Arts,
Houston, the Robert Lee Blaffer Memorial
Collection, gift of Sarah Campbell Blaffer,
55.103.

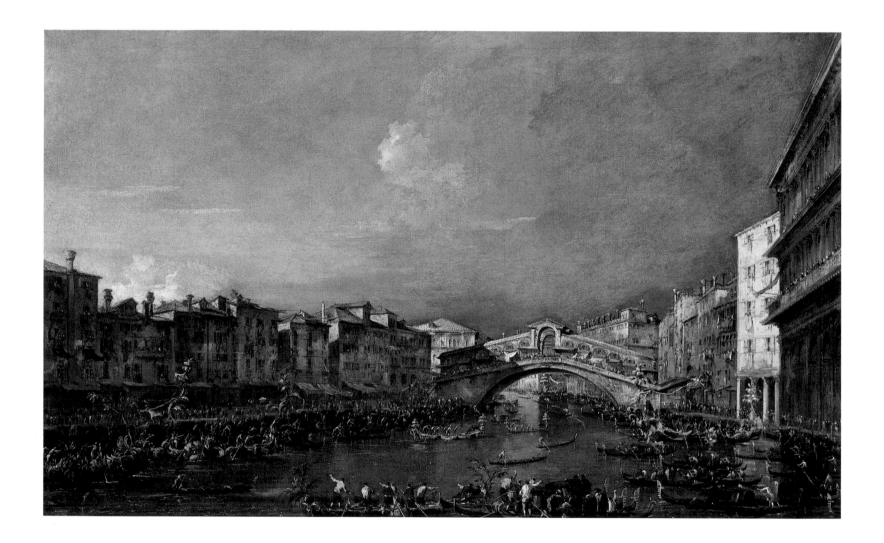

Plate 33. Francesco Guardi (Venice 1712-Venice 1793), *Regatta at the Rialto Bridge*, 1770s, oil on canvas, 30½ x 49½ in.

Working from memory, for Lingelbach painted his *capriccio* after leaving Italy,[4] he made no attempt to represent the buildings accurately, but did convey, as Panini would not, the ongoing life of the city.

In Venice, the emphasis was not on monuments but on the city and its dazzling conjunction of sky and water. The most successful of all Venetian view painters was Antonio Canal, known as Canaletto. An expert draftsman, he also had a good memory for lively action in his figures, which he painted in a rapid manner with bright spots of white and color. Above all, Canaletto's great talent was in making the viewer feel he is there. In *The Grand Canal, Entrance Looking West* (plate 31), the viewer glides into the painting as if he were in a gondola directly behind those entering at the lower edge. Ahead in the sunlight, the Grand Canal winds toward the Rialto Bridge. If you had been to Venice, this is how you remembered it; if you hadn't been, you wanted to go.

To the left of the domed Church of Santa Maria della Salute is the Dogana, or customs house. There is an unintentional irony in the juxtaposition of these two buildings, still standing side by side. Santa Maria della Salute was erected by the city during the seventeenth century in thanksgiving to the Virgin for a temporary subsidence of the plague. The plague, which afflicted Venice regularly, was carried by rats who arrived as unwanted cargo on the ships that checked in at the customs house and supported the wealth of Venice.

Admired in our own century as the most painterly of the view painters, Francesco Guardi never attained the success of Canaletto. By contrast to Canaletto's lively but precise style, Guardi uses a sketchy, almost staccato technique. In *Regatta*

Plate 34. Michele Marieschi (Venice 1710-Venice 1743), *View of the Dogana and Santa Maria della Salute*, n.d., oil on canvas, 21¼ x 32½ in.

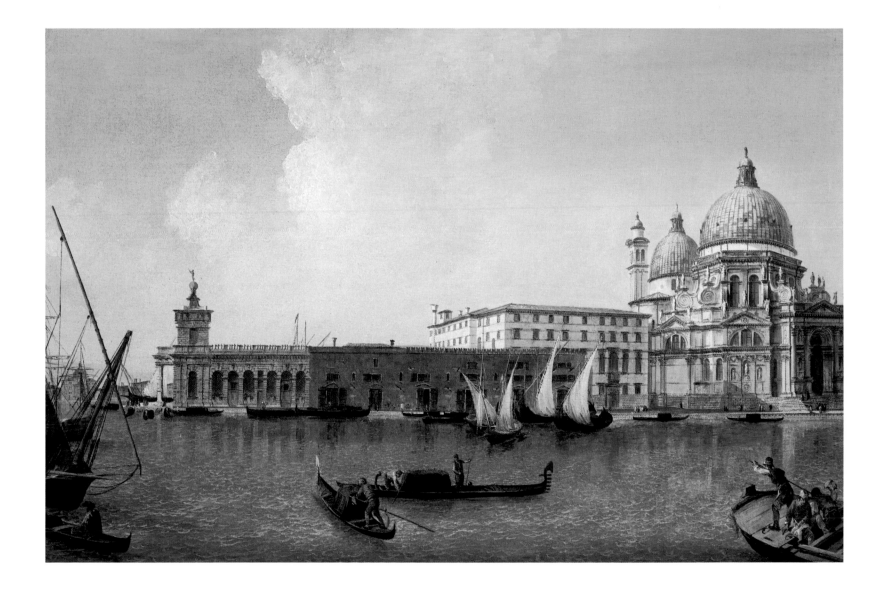

Plate 35. George Morland (London 1763-London 1804), *View at Enderby, Leicestershire*, 1792, oil on canvas, 34 x 46 in.

at the Rialto Bridge (plate 33), flicks of paint set the scene in motion: the light sparkles, the boats jostle and dart about, and the figures gesticulate. Here and in other views, Guardi painted the life of Venice as a series of momentary impressions that would linger in the mind of the traveler long after he had departed. The exhibition also includes a view of the church of Santa Maria della Salute by Michele Marieschi (plate 34), which should be compared to Canaletto's painting of the same subject (plate 32).

In the second half of his career, Canaletto spent several years in England,

Plate 36. Jean-Baptiste Huet (Paris 1769-Paris 1823), *Landscape with Shepherdesses and Fishermen*, 1793, oil on canvas, 21¼ x 25⅝ in.

where he painted a number of English scenes. Though the English were collectors of Renaissance and baroque art, no school of English painting comparable to one on the Continent appeared until the eighteenth century, and then its principal achievement was in portraiture. English views by English artists attracted few patrons. Had there been a buying public for paintings of the English countryside, as there would not be until the nineteenth century, Thomas Gainsborough might be known for his landscapes rather than for his portraits, for he was strongly attracted to English landscape.[5] Gainsborough, like his contemporary George Morland (plate 35) or the Frenchman Jean-Baptiste Huet (plate 36) did paint some imaginary country views with farm workers, sheep, or cattle in the tradition of pastoral landscape. By contrast, Gainsborough's late painting *Coastal Scene with Shipping and Cattle* (plate 37) in its gray tonality and subject derives directly from such Dutch painters as Jan van Goyen and Aelbert Cuyp.[6] *Dovedale by Moonlight* (plate 38), a night scene in the valley of

Plate 37. Thomas Gainsborough (Sudbury 1727-London 1788), *Coastal Scene with Shipping and Cattle*, c. 1781-82, oil on canvas, 30 x 25 in.

the Dove River, by Joseph Wright of Derby is influenced by the night scenes of the German artist Adam Elsheimer (1578-1610),[7] but the painting is exceptional in its representation of an English subject and in the absence of any human figure. In other works, Wright painted to please the English taste for imaginary scenes of Italy (plate 39).

The most dramatic and novel of the English landscapes in the exhibition is *The Display on the Return to Dulnon Camp* (plate 40). Two artists collaborated on the picture: Sawrey Gilpin, who painted the landscape, and Philip Reinagle, who painted the figures and the game.[8] The painting was commissioned by their patron, Colonel Thomas Thornton, to record a successful hunting and fishing expedition in the Scottish Highlands. As the two artists have presented the scene, the Colonel and his companions

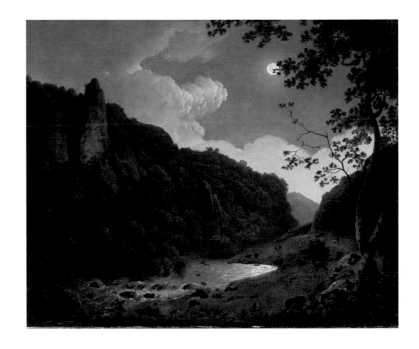

Plate 38. Joseph Wright of Derby (Derby 1734-Derby 1797), *Dovedale by Moonlight*, c. 1785, oil on canvas, 24½ x 29¼ in.

Plate 39. Joseph Wright of Derby (Derby 1734-Derby 1797), *Italian Landscape with Mountains and a River*, c. 1790, oil on canvas, 20½ x 30½ in.

Plate 40. Sawrey Gilpin
(Scaleby 1733-Brompton 1807), and
Philip Reinagle (Edinburgh? 1749-
Chelsea 1833), *The Display on the
Return to Dulnon Camp, August, 1786*,
1786?, oil on canvas, 44¼ x 64 in.

are dwarfed by the mountains and surely deafened by the rushing torrent of the Dulnon River, which plunges across the center of the painting. There is no inducement for the viewer to enter the picture. Inspired by the rugged surroundings of the actual site, Gilpin has represented nature in a wholly new guise, wild nature, arousing feelings of grandeur and awe. Painted in 1786, the work stands at the threshold of the Romantic movement. Gilpin's landscape is not without precedent in earlier painting. The seventeenth-century Italian artist Salvator Rosa became famous for similar scenes of plunging waterfalls and rocky cliffs, but in its appreciation for the wild beauty of the Scottish Highlands, the English painting was ahead of its time. Walter Scott would not publish *Waverley*, his first novel of the Scottish Highlands, until after the beginning of the next century.

NOTES

[1] CLARK, pp. 29ff. and 54ff.
[2] STECHOW, p. 39ff.
[3] ROSENBERG, p. 276.
[4] WRIGHT, p. 154.
[5] CLARK, p. 34.
[6] BUTLIN, p. 108.
[7] BUTLIN, p. 114.
[8] BUTLIN, p. 78.

Genre Painting

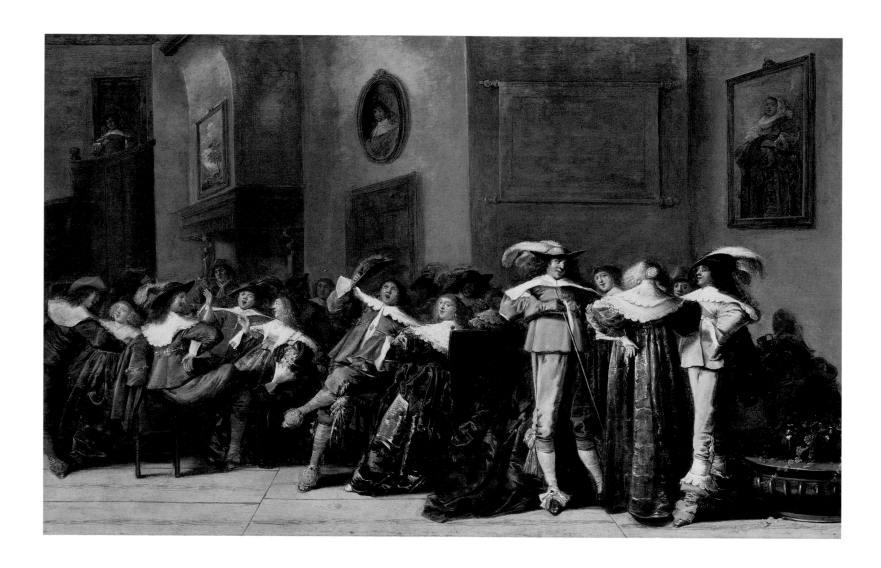

Plate 41. Dirck Hals (Haarlem 1591-
Haarlem 1656), *The Merry Company*,
1630s, oil on panel, 20½ x 32¾ in.

Genre Painting: Comedy and Commonplace

GEORGE T. M. SHACKELFORD

I n the late sixteenth century, paintings of incidents of daily life, unencumbered by overt historical or religious subjects, began to be popular in numbers that had not been seen before. In the Netherlands especially, these paintings captured the imagination of the art-loving public. Painters in Amsterdam, Haarlem, Leiden, or Delft found a ready market for their hundreds of pictures of life among the noble and humble classes. Images of courtly entertainments, of the light-struck interiors of merchants' houses, of skating on frozen canals, or of peasants brawling in an inn—all of these were prized for their expressiveness, for their truth to nature, for the charm with which they told their little stories of commonplace experience. Although in their time they were almost always called by their specific subjects or locales—kitchen, guardroom, merry company, or brothel—today we classify all these images under the term "genre".

The word *genre*, from the French for kind, sort, or type, was applied by seventeenth- and early eighteenth-century writers to all the types of art—"*les genres*"—that were not at the elevated level of history painting—"*le grand genre.*"[1] Over the course of the seventeenth century, a critical vocabulary for still life, landscape, and portrait painting gradually emerged, and these types were seen as distinct from the representation of everyday human events. By the mid eighteenth century, Diderot would comment that history painters scorned painters of genre as "men of paltry little subjects, of little domestic scenes taken from the street corner." A generation later, the French academician Quatremère de Quincy still referred to the concept of the several lower genres, but tried to define the word more precisely, writing that "genre properly speaking . . . [was] that of bourgeois scenes." Only in the mid nineteenth century did the word find broad currency in the way we use it today, first in Germany and then in the English-speaking world.[2]

Questions of historical usage aside, it is still difficult for us to arrive at a precise definition of genre. By general agreement, we understand that genre paintings represent typical events of life in the past or present; they must represent human beings, but they do not represent identifiable individuals, as do portraits or paintings of singular historical events or of literary subjects. Under these criteria, genre art encompasses such widely divergent images as the household scenes painted on Greek vases and the city dwellers of Edward Hopper. The people represented in genre paintings are meant, as the historian Max Friedländer has observed, to be anonymous. "Anonymity is the genre's idiosyncracy," he wrote. "Because we do not know the

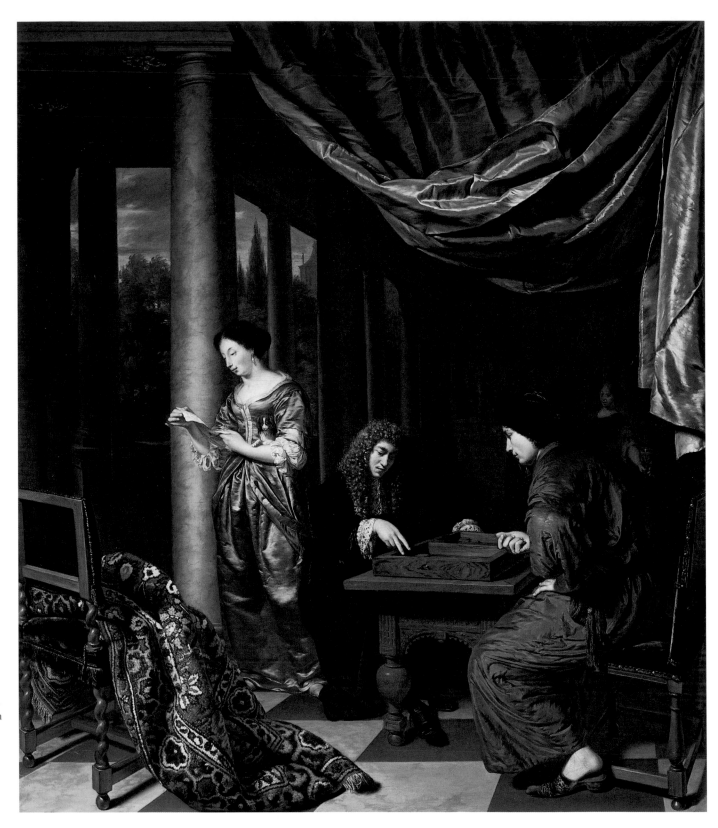

Plate 42. Frans van Mieris the Elder (Leiden 1635-Leiden 1681) with Willem van Mieris? (Leiden 1662-Leiden 1747), *Interior with Figures Playing Trictrac*, 1680, oil on canvas, 30½ x 26½ in.

names, are not interested in them, the common human condition is revealed and, within that condition, class, sex, age, mother, child, soldier, lady."[3]

The art-loving public of early seventeenth century Holland would have been puzzled by our effort to define a term for the paintings of daily life that they appreciated without categorizing. As recent scholars have shown, little was written about genre painting in the first three quarters of the seventeenth century, the period of the greatest flowering of genre in Western art. In these years, massive quantities of such works were produced for a market that was much more diverse than we might imagine, encompassing not only wealthy patrons but a broad span of collectors from the middle classes.[4] This spectrum is mirrored, interestingly enough, in the diversity of subjects treated by the artists, which range from the drawing rooms of genteel or aristocratic society through the comfortable homes of the bourgeoisie to the brothel and the humble barroom.

Dirck Hals's *Merry Company* (plate 41) typifies the scenes of highlife favored by some genre painters in the early decades of the century. It shows an elegant interior, hung with portraits, a landscape, and maps, in which a crowd of richly dressed ladies and cavaliers are shown laughing, talking, drinking, and smoking, attended by servant boys at right and a musician at the upper left. Dirck Hals was the younger brother of the portrait and genre artist Frans Hals (whose *Portrait of a Woman*, plate 57, is also in this exhibition), and like his brother showed a gift for rendering light as it was scattered over surfaces of feathers, silks and lace. Here his color scheme is especially well-chosen: the muted costumes of the men, in a range of browns and grays, harmonize with the planks of the floor and the plaster of the walls, acting as a foil for the jewel colors of the women's high-waisted dresses, shown in tones of blue, green, red, and gold. The figures posture and preen, aware of the elegance of their gestures: three members of the company pose with their hands placed rakishly on their hips. Two women, who turn their heads to engage the spectator, show that they are aware that the company is assembled in part to be looked upon.

This type of courtly scene found particular popularity among a group of artists working in Leiden, who were called *fijnschilders*—fine painters—because of their love of highly-finished surface detail. Gerard Dou (1613-1675), Gabriel Metsu (1629-1667), and Frans van Mieris were the best-known painters of this group. The Blaffer Collection's *Interior with Figures Playing Tric-trac* (plate 42), which may have been painted by Frans van Mieris in collaboration with his son Willem, is a beautiful example of *fijnschilder* style, with its exquisitely rendered marble floor and columns, polished wood, silk robes, and Turkey carpet, and its clever illusionistic curtain, pulled back to the top right to reveal the scene below, almost as if it were a curtain hung by a collector over his picture.

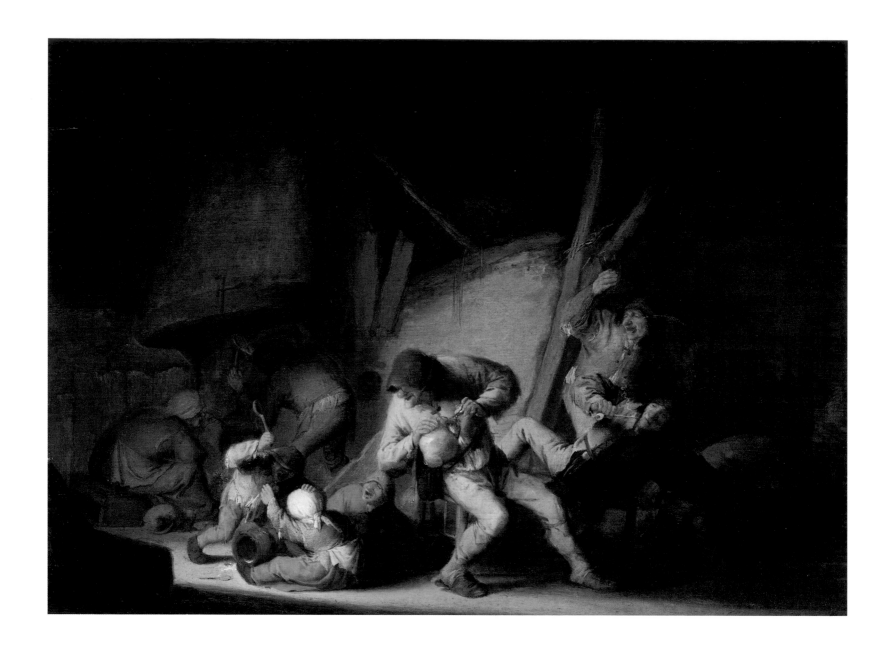

Plate 43. Adriaen van Ostade (Haarlem
1610-Haarlem 1685), *Interior with
Drinking Figures and Crying Children*,
1634, oil on canvas, 12¼ x 16⅞ in.

At the opposite end of the spectrum from the *fijnschilders* of Leiden is the work of Adriaen van Ostade, like the Hals brothers a native of Haarlem, whose boisterous *Interior with Drinking Figures and Crying Children* is exhibited here (plate 43). This fine panel, dated 1634, is among Ostade's earlier mature works, and clearly reveals his interest in low-life scenes, images of villagers or peasants in humble interiors, in courtyards, by cottage doors, or, as here, roustering in a room that seems half cottage, half barn. In the spirit of his predecessor Adriaen Brower (1606-1638), Ostade delighted in showing the extreme conditions of humanity; the adults are grouped at right, bellowing drunkenly, while the children wrangle at left, spilling their pot of milk or gruel.

Such lowlife imagery has its roots in the depiction of village fairs in the work of such Flemish artists as Pieter Bruegel (c. 1525-1569). We can see the continuation of the tradition in the work of the Flemish painter David Teniers the Younger, whose *Soldiers Playing Dice* (plate 44) is shown in this exhibition, or in the figures in the foreground of Lingelbach's *Capriccio View of Rome* (plate 30). But the work of Jan

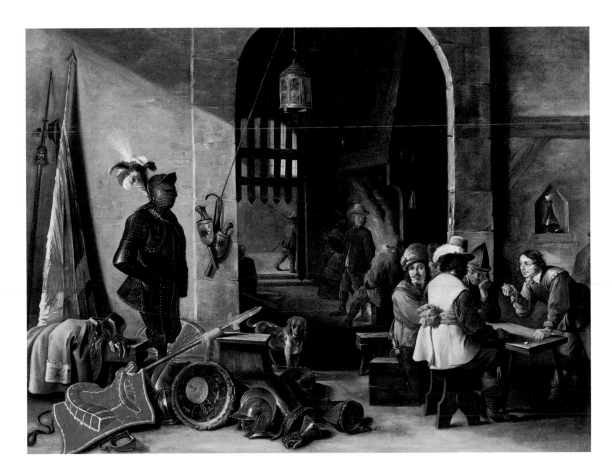

Plate 44. David Teniers the Younger (Antwerp 1610-Brussels 1690), *Soldiers Playing Dice*, c. 1630s, oil on copper laid on panel, 21½ x 28⅞ in.

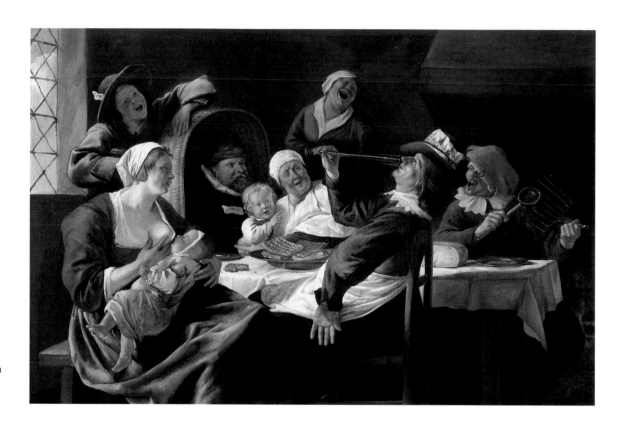

Plate 45. Jan Steen (Leiden 1626-Leiden 1679), *The Twelfth Night Feast*, 1670s, oil on canvas, 26⅝ x 38⅝ in.

Steen, whose *Twelfth Night Feast* (plate 45) is in the Blaffer Collection, is the most perfect expression of this comic tradition in Dutch genre painting of the period. Steen, himself an innkeeper as well as a painter, gained a reputation as a drunkard, although that reputation seems to be undeserved.[5] Here, a family is shown around a table at a meal to celebrate the holiday of Epiphany. Three figures—a boy, an old woman (a disguised self-portrait) and a man at far right—are shouting, singing, or laughing at the drinking man at the center, crowned with a bit of paper stuck into his hat. (Curiously enough, this figure is almost a parody of the type of elegant figures seen in the *Merry Company* by Dirck Hals.) It is worth noting, too, that Steen was an accomplished painter of histories; like Shakespeare, he recognized the poetic possibilities of both the comic and tragic modes.

Although the focus on the human condition or aspects of everyday life predisposed the genre painter to interior views, there are many genre paintings that have landscape for their settings. These paintings frequently give the impression of belonging to a hybrid category, poised as they are between being images of the landscape and of the typical activity that takes place in that landscape. Landscape painters such as Lingelbach (plate 30) or Canaletto (plates 31 and 32) employed incidental figures to enliven the foregrounds of their views. In the case of Egbert van der Poel's *Skating*

Scene (plate 46), which probably represents a view in Rotterdam, the recreational activity is given greater prominence, and treated as the motive for the picture, rather than as an embellishment of the landscape. Similarly, Wouwerman's *Soldiers Plundering a Village* (plate 47), while describing a splendidly observed atmospheric vista, is dominated by the moving record of destruction in the foreground, which curiously enough may have been a typical activity in the warring Netherlands of the 1660s.

Genre developed most richly in the Low Countries, following traditions established by Netherlandish painters of the Renaissance, but artists working in other European centers contributed to the development of its traditions in the seventeenth century. Both the Carracci (fig. 2) and

Plate 46. Egbert van der Poel (Delft 1621-Rotterdam 1664), *A Skating Scene*, 1656, oil on panel, 14 x 19 in.

Caravaggio, of course, were instrumental in the diffusion of genre-like images in the realist movements of the last years of the sixteenth century; in the thrall of Caravaggio's naturalism, the Spanish painters Diego Velazqucz (1599-1660) Juan Esteban Murillo (1617-1682) and Jusepe de Ribera (1591-1652), the latter working in Italy, extended the range of genre types. But the investigation of genre imagery begun in the circle of the Carracci was largely abandoned in Italy for more than one hundred years, until such painters as Giuseppi Maria Crespi (1665-1747), Giambattista Piazzetta (1683-1754), and Pietro Longhi (1702-1785) revived interest in such themes in the first half of the eighteenth century.[6]

At about the same time, the hegemony of history painting was being challenged in French academic circles by artists working in genre. Jean-Antoine Watteau, the painter of soldiers' encampments, country fairs,

Plate 47. Philips Wouwerman (Haarlem 1619-Haarlem 1668), *Soldiers Plundering a Village*, 1660s, oil on panel, 18⅞ x 25⅛ in.

Plate 48. Nicolas Lancret (Paris 1690-
Paris 1743), *The Captive Bird*, c. 1730,
oil on canvas, 11⅜ x 15⅝ in.

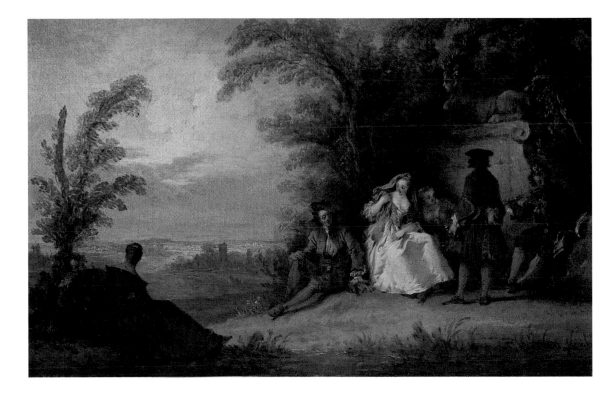

Plate 49. Bonaventure De Bar (Paris 1700-Paris 1729), *Fête Champêtre*, late 1720s, oil on canvas, 7 x 11½ in.

and amorous proposals, presented himself for admission to the Academy in 1712. In a rare exception to the control usually exercised by the Academy, Watteau was permitted to select his own subject for the reception piece. After much delay, Watteau was received into the Academy five years later, in August 1717, with a quasi-allegorical painting of lovers in a landscape, a *fête galante*, as it was styled in the Academy's record book. Although the title of the painting, *Pilgrimage to Cythera*, placed the work in an acceptably mythological context, the figures were resolutely modern in their attitudes and in their theatrical dress.[7]

The academy's acceptance of genre subjects followed the taste of the Parisian art market, which had seen a distinct increase in the popularity of seventeenth-century Dutch and Flemish paintings.[8] Two years after Watteau's reception into the Academy, the painter Nicolas Lancret was received with a *Conversation galante;* one of his "fancy pictures," *The Captive Bird* of c. 1730, is exhibited here (plate 48). Jean-Baptiste Pater (1695-1736) and Bonaventure De Bar were received in 1728, both with pictures of country dances or fairs. At the center of De Bar's *morceau de reception*, now in the Louvre, we find the figures present in the Blaffer Collection painting (plate 49), which must be either a study related to the development of the larger composition or a replica of its central motif.

Throughout the century, while their counterparts in history painting took their

cues from the art of Italy, French painters working in genre retrieved and revised the types that had been established by Netherlandish genre painters of the Golden Age. It is generally acknowledged that Dutch sources were far more important to French painters than were native French antecedents, such as the work of the brothers Le Nain. Beginning in the 1730s, Jean-Baptiste Siméon Chardin explored a range of genre compositions—set in kitchens and sculleries, or in drawing rooms—that remind us of the works of van Mieris, Metsu, and, above all, of Gerard ter Borch (1617-1681). Chardin's *Good Lesson* in Houston (fig. 6), a late genre work of of 1749-53, glows with the light of seventeenth-century Holland, falling through the window curtains on the figures of governess and young girl, reciting her Bible verse in this spare interior.

While Chardin emulated the light effects of Netherlandish painting of the previous century, the Rococo painter Jean-Honoré Fragonard was captivated by the free touch of painters such as Rembrandt (1606-1669) or Jacob van Ruisdael. Fragonard is known to have copied Ruisdael on more than one occasion—indeed, the Kimbell Art Museum owns a beautiful copy of a landscape by Ruisdael recently acquired by a Houston private collection. Fragonard himself owned works by the master of seventeenth-century landscape, and even went so far as to add a group of figures to an unpopulated Ruisdael view.[9] Rembrandt's influence, equally important, is difficult to detect in the luminous, opalescent decorations of Fragonard's later career; but the Blaffer Collection's *Boy Leading a Cow* (plate 50), a picture of the 1760s, shows in its deep brown shadows and golden light, and in its large and spontaneous brushwork, the important aesthetic lessons that the young Fragonard learned from Rembrandt's example.

Some artists working at the same time were untouched by the style of seventeenth-century Dutch painters, but adapted the forms of Dutch genre paintings to images of fashionable modern men and women in social intercourse. The resulting hybrid, called the Conversation Piece, was popular throughout Europe. When the figures are anonymous, as in the case of Lancret's *conversation galante*, or early genre pictures by François Boucher (1703-1770) or Jean-François de Troy (1679-1752), the pictures remain comfortably within the category of genre.[10] On the other hand, following Friedländer's criterion of anonymity, when we can identify the figures as known individuals we classify such paintings not as genre pictures but as portraits. As Susan Barnes points out in her essay on portraiture in this catalogue, this is the case with Thomas Beach's *The Hand that Was Not Called* (plate 60). It was the example of French *conversations* by Boucher that most influenced such a painter as Philippe Mercier, born to a Huguenot family in Berlin, who in the early 1740s painted a large and impressive picture of a *Girl Pulling on Her Stocking* (plate 52). Mercier was

Fig. 6. Jean-Baptiste Siméon Chardin (Paris 1699-Paris 1779), *The Good Lesson*, c. 1753, oil on canvas, 16¹⁵⁄₁₆ x 18⅝ in., the Museum of Fine Arts, Houston, gift in memory of George Brown by his wife and children, 85.18.

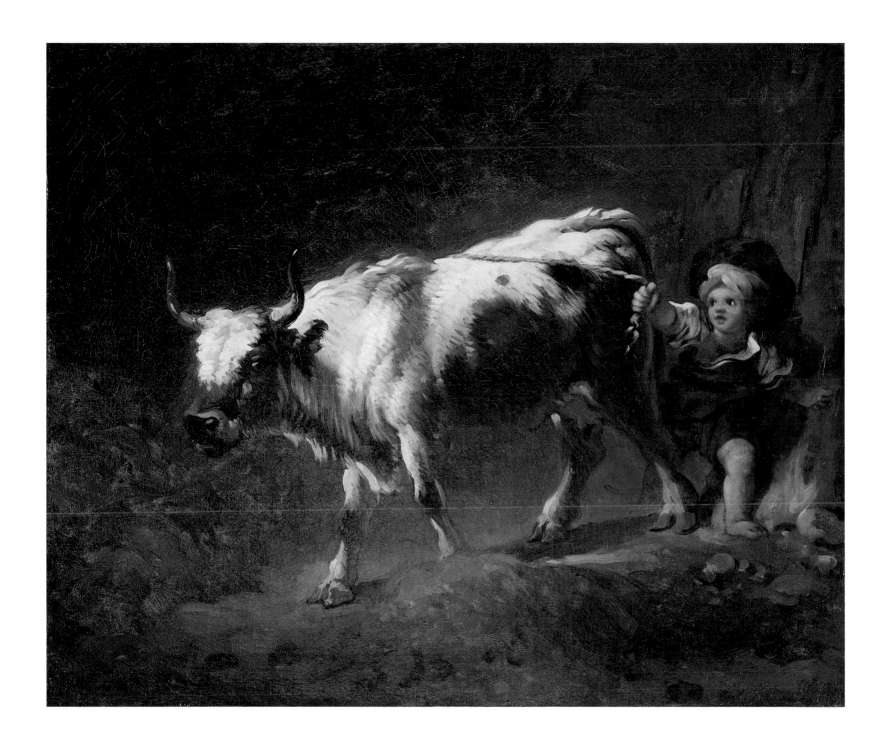

Plate 50. Jean-Honoré Fragonard (Grasse 1732-Paris 1806), *A Boy Leading a Cow*, c. 1760s, oil on canvas, 21¼ x 26 in.

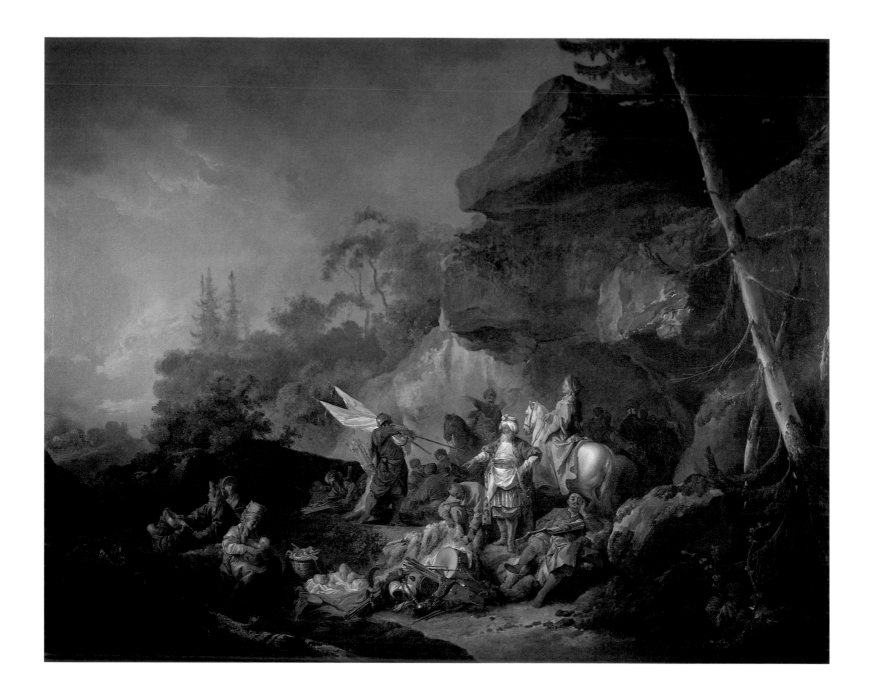

Plate 51. Jean-Baptiste Leprince (Metz 1734-Saint Denis-du-Port 1781), *The Tartar Camp*, c. 1765, oil on canvas, 69 x 87¾ in.

principally active in England, practicing in the Watteau manner and developing the concept of the "fancy picture" in the generation of William Hogarth (1697-1764), the greatest storyteller among the genre painters of eighteenth-century England.

By the time of Hogarth's death in the mid 1760s, the practice of genre painting was firmly established and accepted by the public in every corner of Europe. In France, the genre paintings of Chardin, Boucher, Fragonard, or Jean-Baptiste Greuze

(1725-1805), avidly collected by the most discriminating connoisseurs, rose to a position of considerable importance—so much so that since the nineteenth century, these paintings have eclipsed almost completely the reputation of religious or history paintings of the period. Genre art conveys more vividly than any other the image of eighteenth-century France, as the impressions of Parisian society painted by Manet, Degas, or Renoir one hundred years later are the most lasting images of the Second Empire and its aftermath. Because of this phenomenon, it is difficult for a modern public to understand why Greuze, certainly at his best when painting scenes of everyday life, should have been so gravely humiliated when the academy admitted him to its ranks not as a history painter, but as a *peintre de genre*. Greuze no doubt believed that his carefully constructed moral tales were, in the words of Diderot, "just as much history paintings as the *Seven Sacraments* of Poussin, the *Family of Darius* by Lebrun, or Vanloo's *Susannah*."[11] Many academicians—like the public—may have felt the same, but the body considered it appropriate to distinguish between the value of history and genre, to rebuke Greuze by affirming once again the hierarchy of the genres and the priority of history.

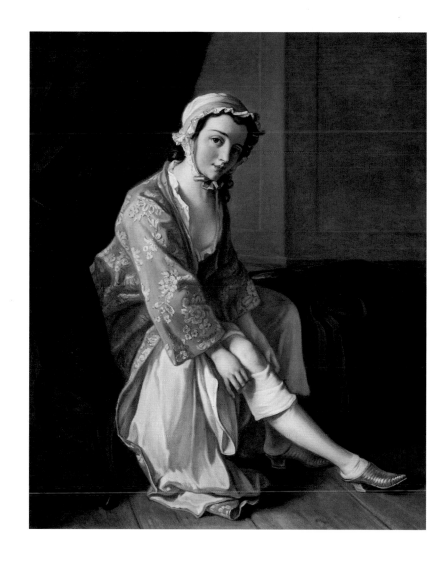

Plate 52. Philippe Mercier (Berlin 1689-London 1760), *A Girl Pulling on Her Stocking*, c. 1745-50, oil on canvas, 55 x 40 in.

NOTES

[1] See SUTTON, p. xiv; also STECHOW & COMER.
[2] Diderot and Quatremère de Quincy as quoted in STECHOW & COMER, p. 91, on usage, see pp. 92-94.
[3] See FRIEDLÄNDER, p. 155.
[4] See SUTTON, pp. xv-xviii.
[5] See SUTTON, p. 307.
[6] For an investigation of the rise of genre painting in the late seventeenth and eighteenth centuries in Italy, see Mira Pajes Merriman, "Comedy, Reality, and the Development of Genre Painting in Italy," in SPIKE 1986, pp. 39-76.
[7] GRASSELLI & ROSENBERG, pp. 21-23, 396-401.

[8] HOLMES.
[9] ROSENBERG, p. 184; the Kimbell Fragonard and the Ruisdael in a Houston private collection are figs. 1 and 2.
[10] See, for example, Boucher's *Le déjeuner*, 1739, Musée du Louvre, or Jean-François de Troy's *The Reading from Molière*, c. 1728, the Marquess of Cholmondeley, reproduced in CONISBEE, fig. 131, pl. 11.
[11] For the story of Greuze's reception, see Edgar Munhall, *Jean-Baptiste Greuze / 1725-1805*, exh. cat. (Hartford: *The Wadsworth Atheneum*, 1976), pp. 12-13.

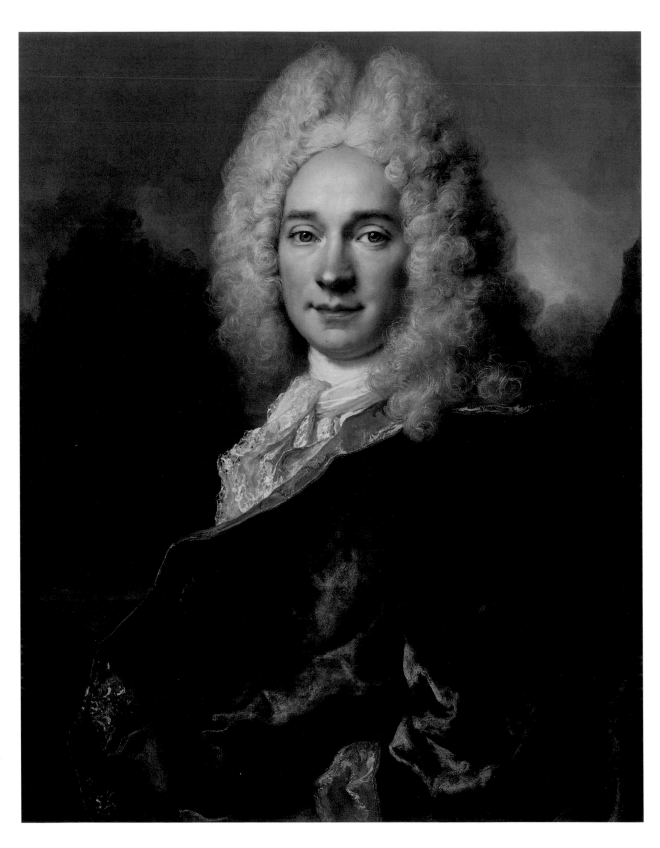

Plate 52. Nicolas de Largillière
(Paris 1656-Paris 1746),
*Portrait of Pierre Cadeau de
Mongazon*, c. 1720(?), oil on
canvas, 32 x 25½ in.

Portraiture, in Balance between the Ideal and the Real

SUSAN J. BARNES

At the end of the sixteenth century, a new generation of artists converging in Rome rejected the artifice of the Tuscan and Roman Mannerism that then held sway. Early seventeenth-century masters such as Caravaggio (1571/72-1610) and Annibale Carracci (1560-1609) turned with conviction to creation based on visual reality. An attitude of faithfulness to nature—that is to the depiction of forms, colors, textures, atmosphere, and light as they can be perceived—underlies the oeuvres of these influential giants and their seventeenth-century successors.

For portraiture, which had become locked into rigid formulas at the sixteenth-century courts of Europe and England, the return to nature opened an era of such fertile invention that its legacy was almost without end. Beneath the changing fashions of costume and of painterly handling, the portrait forms born early in the seventeenth century endured three hundred years more. The key to that survival was their attention to and respect for "nature," both in its outward and inward sense, that is to the sitter's lifelike appearance and demeanor but also to the more essential, elusive, animating impact of personality.

Portrait painters of the early seventeenth century rediscovered and mined the rich heritage of the High Renaissance. In keeping with the "interest in human motives and the human character . . . that lay at the center of Renaissance life,"[1] Raphael (1483-1520) and Leonardo (1452-1519), among other great painters in the age of Humanism, had turned their thoughts and their hands to portraiture. Beyond the mere physical aspects of appearance and the newly mastered illusion of atmosphere and chiaroscuro, Leonardo wrote that the portrait should convey "the motions of the mind."[2] Sebastiano del Piombo's commanding *Portrait of Anton Francesco degli Albizzi* (fig. 7) is just such an achievement. It is a likeness of astonishing veracity and of presence, conveyed principally through Albizzi's gesture. More than anything else, that sense of vital presence in the moment was the Renaissance legacy to portraits of the seventeenth and eighteenth centuries.

In considering the later critical fortunes of the portrait and its place in the hierarchy of the genres, we should bear in mind the engagement of important early figures in the Renaissance with the problems of portraiture. Following ancient texts, Leon Battista Alberti held that the portrait should ennoble its subject; for him *bellezza* and *idea*—the beautiful and the ideal—took precedence over the faithful reproduction of nature.[3] We can understand how the humanist would want to celebrate and immortal-

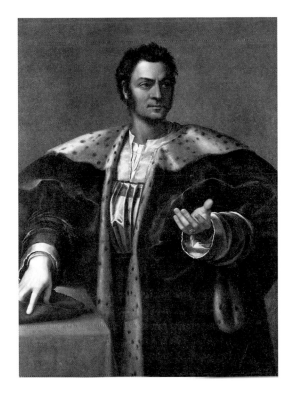

Fig. 7. Sebastiano del Piombo (Venice? c. 1485-Rome 1547), *Portrait of Anton Francesco degli Albizzi*, c. 1524/25, oil on canvas, transferred from panel, 53 x 38⅞ in., the Museum of Fine Arts, Houston, the Samuel H. Kress Collection, 61.79.

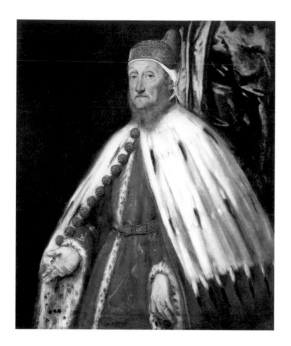

Fig. 8. Jacopo Robusti, called Tintoretto (Venice 1518-Venice 1594), *Portrait of Doge Pietro Loredan*, 1567-70, oil on canvas, 49½ x 41¾ in., the Kimbell Art Museum, Fort Worth.

ize the image of actual heroes. Subsequent theory would give the portrait priority among the lesser genres, placing it second only to the depiction of sacred and profane history.

It was the very naturalism of portraiture, its inherent responsibility to represent or imitate the living model, that opened it to the disdain we know from certain Italian texts. G.B. Armenini's condemnation at the end of the sixteenth century was most concise: "We needn't waste time learning the ways of portraiture, because a mediocre talent can manage them once he is competent in the use of color and has enough experience to remember real hues."[4] But critical attitudes toward portraiture were by no means uniform, even within sixteenth-century Italy. For instance, sixteenth-century theorists Paolo Pino and Ludovico Dolce valued the verisimilitude of the portrait. Their attitudes demonstrate that the hierarchy of the genres governed painting less strictly in Venice, where they were writing, than in Rome and Florence, where academies were founded in the late sixteenth century.[5] Outside of Italy and within, respect for the hierarchy is aligned with academies of art. The exception to this rule is Antwerp, which had no academy, but where two generations of "Romanists" in the sixteenth century had adopted the Italian attitudes and studio methods that Peter Paul Rubens (1577-1640) was to take up.

The most important theorist writing on the eve of the seventeenth century dedicated an entire chapter of his 1584 treatise on painting history to the portrait. Giovanni-Paolo Lomazzo praised the ancient role of portraiture, which preserved for the edification of future generations the images of great leaders and virtuous men. He analyzed the ills into which the genre had fallen subsequently and proposed remedies. Like Alberti before him, Lomazzo held up ideals for the portrait, including the artist's duty to mask the "defects" of nature, as the ancients had, and to follow standards of decorum for the dress, attributes, and bearing of those depicted.[6] According to Lomazzo, it was the responsibility of the portraitist to *create an image* in which the appearance and bearing of the sitter correspond to the ideal of that person's place in society. Lomazzo's ideas found form in the portraits of Rubens, Van Dyck, and Velazquez, among many others.

Venice was the center of portraiture throughout the sixteenth century, the home of Giorgione (c. 1476/8-1510), Lorenzo Lotto (c. 1480-1556), and Titian (c. 1487/90-1576), the greatest portraitist of all time. Titian's immediate successors responded to the lively demand by portrait patrons in two categories. Tintoretto and his shop provided images of officials in the Venetian Republic, such as the regal *Portrait of Doge Pietro Loredan* in the collection of the Kimbell Art Museum, Fort Worth (fig. 8). Veronese, on the other hand, painted elegant icons for the aristocracy and wealthy merchants.[7] Animated by a leaning pose and a wide-eyed gaze that

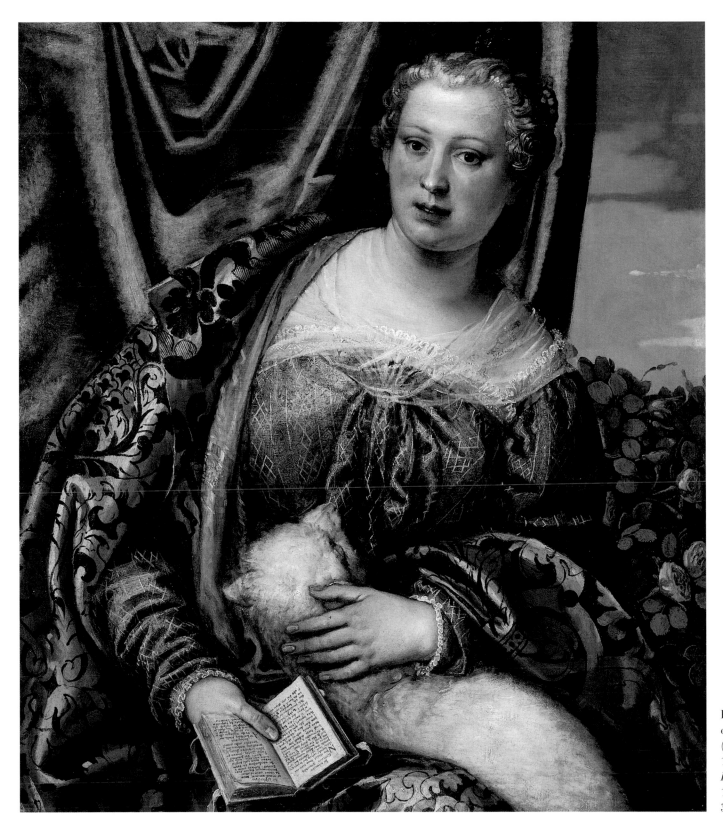

Plate 53. Paolo Caliari, called Veronese (Verona 1528-Venice 1588), *Portrait of a Lady as St. Agnes*, 1580s, oil on canvas, 34 x 29½ in.

together suggest we have interrupted her reading, the *Portrait of a Lady as St. Agnes* (plate 53) has that momentary quality, that sense of immediate presence, that the generations following would emulate. The attributes of the missal and the lamb signal this unknown woman's disguise as St. Agnes. But the picture has an aesthetic force that carries it beyond the realm of an historiated portrait. Veronese's rich colors and glowing light—the splendor of his painting—and the sheer beauty of the sitter remind us that in the Renaissance the depiction of a beautiful woman could be the measure of the beauty of painting itself. As such, it could represent the victory of painting in the *paragone* with poetry.[8]

More than any other painter, Anthony Van Dyck seized the legacy of Venetian portraiture and conveyed it to later generations throughout Europe. Enamored of Venetian technique even as a boy, while in Italy Van Dyck carefully studied the subtleties of gesture, movement, and psychology of Titian's portraits, and the vitality and sumptuousness of Veronese's. In commissions for the Genoese patriciate, and later at the English court of Charles I, he developed the full-length, aristocratic forms for which he is best known. Such works drew on the forms and devices of religious painting to raise portraiture to a new level of dignity and poignancy.

Plate 54. Italian, Roman school,
Pope Gregory the Great, c. 1620(?),
oil on canvas, 49½ x 38¼ in.

Equally important for the history of portraiture, however, were Van Dyck's informal images, such as his *Portrait of Anton Triest, Bishop of Ghent* (plate 55). Lips parted, and hand raised as if to stress a point of discussion, Bishop Triest is a veritable "speaking likeness," of the kind we associate with the great marble portraits by Gianlorenzo Bernini (1598-1680). Like his contemporary Bernini, Van Dyck honed his interest in this type early on in Rome, following the model of Ottavio Leoni's portrait drawings.[9] Also in emulation of Leoni (1575-1628) and following the spirit of the Renaissance *uomini illustri*, Van Dyck etched Bishop Triest's portrait for a series of prints celebrating distinguished figures of his day.[10]

In theory and in practice, Roman art was centered on the structures and the subjects of the Church. Artistic patronage lay principally with the popes, who in the seventeenth century directed it to celebrating the success of Catholicism in overcoming the Protestant challenge around Europe. The imaginary portrait of the sixth-century *Pope Gregory the Great* (plate 54) apparently belonged to a quartet representing the four Latin Doctors of the Church. It stands outside the history of portraiture *per se*, belong-

Plate 55. Anthony Van Dyck
(Antwerp 1599-London 1641),
Portrait of Antoine Triest,
Bishop of Ghent (1576-1655),
c. 1627, oil on canvas,
31½ x 25⅛ in.

Plate 56. Ferdinand Bol, (Dordrecht 1616?-Amsterdam 1680?) *Portrait of a Man (Lord Hebdon?)*, 1659, oil on canvas, 52½ x 42 in.

ing instead to the traditions of religious imagery. The patron and original location of this painting are unknown, but the existence of other versions (including one in the Prado, paired with *St. Augustine*) suggests they were widely distributed for didactic purposes. Such a "likeness" asserts both the ancient lineage of Catholicism and, through the dove of the Holy Spirit, the divine favor bestowed upon the founders of the Church.

Van Dyck's aristocratic portraiture had a far-reaching influence during his lifetime and long thereafter. Near in time and space is Ferdinand Bol's *Portrait of a Man* (plate 56), whose dramatically designed curtain and carefully articulated hand bear the trace of Van Dyck's style. Those similarities could support the suggestion that the sitter was an Englishman, a patron reared with Van Dyck's portraits who imposed this model on his Amsterdam painter. But the Netherlands had distinguished portrait traditions reaching back to the early sixteenth century, before the Eighty Years War had won independence for the Protestant United Provinces in the north, leaving Catholic Flanders behind under Spanish control. During a long career in Haarlem, Frans Hals maintained and revitalized those traditions, as seen in the Houston *Portrait of a Woman* (plate 57). He depicted prosperous bourgeois men and women at half length in simple, unpretentious surroundings, with an extraordinary vitality of brushwork and light, and with a keen eye for personality, which he often suggested through implied movement.

Unfettered by the hierarchical attitudes of Italy, during the sixteenth and early seventeenth centuries the Netherlands had given birth to the modern genres of painting. The large audience for landscape, portraiture, still life, and genre paintings in that urban materialist society supported an enormous number of specialized painters working for the open market. Bourgeois patrons also commissioned portraits in a variety of different types, including ambitious groups of confreres or family members. In a

Plate 57. Frans Hals (Antwerp 1584-Haarlem 1666), *Portrait of a Woman*, 1650, oil on canvas, 33⁵⁄₁₆ x 27⁵⁄₁₆ in., the Museum of Fine Arts, Houston, the Robert Lee Blaffer Memorial Collection, gift of Sarah Campbell Blaffer, 51.3.

Plate 58. Herman Mijnerts Doncker (c. 1620-working in Haarlem 1653-after 1656), *Family Group*, 1644, oil on canvas, 73⅞ x 99⅛ in.

family portrait (plate 58), Herman Doncker followed the example of Frans Hals—specifically Hals' *Isaac Massa and Beatrix van der Laen* in the Rijksmuseum, Amsterdam—depicting an unidentified family out of doors against a backdrop of fantastic architecture.[11] The setting of Hals's portrait was a garden of love, while Doncker imagined a view of Italian countryside with ancient ruins, but each implies that the sitter is lord of the domain. Lifelike as they may appear, these portraits are confections that represent, in image and symbol, the ideals of their culture and the aspira-

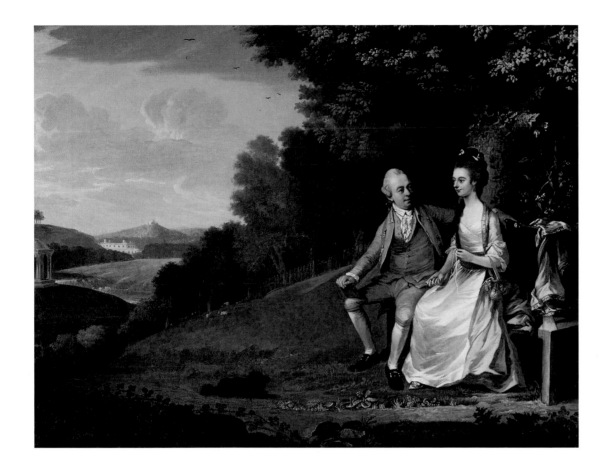

Plate 59. Nathaniel Dance (London 1735-Winchester 1811), *Sir Francis and Lady Dashwood at West Wycomb Park*, 1776, oil on canvas, 28 x 35⅞ in.

tions of the sitters.[12]

Netherlandish group portraits also established the family of portrait types known collectively as the Conversation Piece, which flourished in eighteenth-century England. Different from a genre painting (which it can often resemble), the Conversation Piece depicts two or more actual people engaged in a shared, private activity in a domestic habitat.[13] We recognize Nathaniel Dance's Conversation, the portrait of *Sir Francis and Lady Dashwood* (plate 59), as a very close descendant of Doncker's Dutch family group painted almost a century before. *The Hand That Was Not Called* (plate 60) belongs to another branch, the Conversation Round a Table. Thomas Beach apparently painted this group to commemorate a pivotal moment in the fortunes of the Dutton family (later the Lords Sherborne), when Napier Dutton was saved by a friend from calling a hand of cards and thereby losing his estate. This picture represents a new, hybrid genre that combines portraiture with contemporary history. The British were pioneers in this genre, which more often was dedicated to great political events, such as the *Death of William Pitt, Earl of Chatham* in 1778 by

Plate 60. Thomas Beach (Abbey Milton 1738-Dorchester 1806), *The Hand that Was Not Called*, 1775, oil on canvas, 58 x 74½ in.

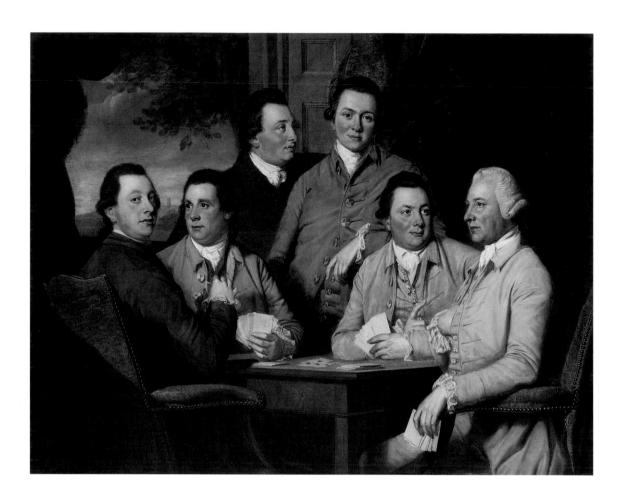

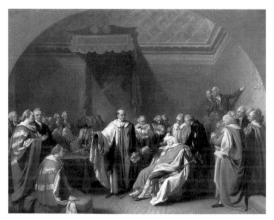

Fig. 9. Benjamin West (Springfield 1738-London 1820), *The Death of William Pitt, the Earl of Chatham*, 1778, oil on canvas, 28⅛ x 36¼ in., the Kimbell Art Museum, Fort Worth.

Benjamin West in the Kimbell Art Museum (fig. 9). This example was followed soon in France.

Like the Dutch, English portraitists practiced in a society free of hierarchical prejudices well into the eighteenth century. With her intense focus on lineage and the eager patronage of her large, landed aristocracy, England nurtured some of the most formidable talents in portraiture, including such imported artists as Holbein and Van Dyck. Formal recognition of the hierarchy of the genres came to England only with the founding of the Royal Academy of Arts in 1768, a full two hundred years after the Florentine academy was established. Ironically, perhaps, it was the famous portraitist Sir Joshua Reynolds who promoted these ancient and Renaissance ideals for painting. The first president of the Royal Academy, Reynolds preached the preeminence of history painting and of the Roman school in many of his annual *Discourses*. His own career, however, was shaped by the reality of custom and his patrons' desires for grand and charming portraits, such as that of *Mrs. Jelf Powis and Her Daughter* (plate 61). Reynolds wrote thoughtfully about the genre, echoing ancient and

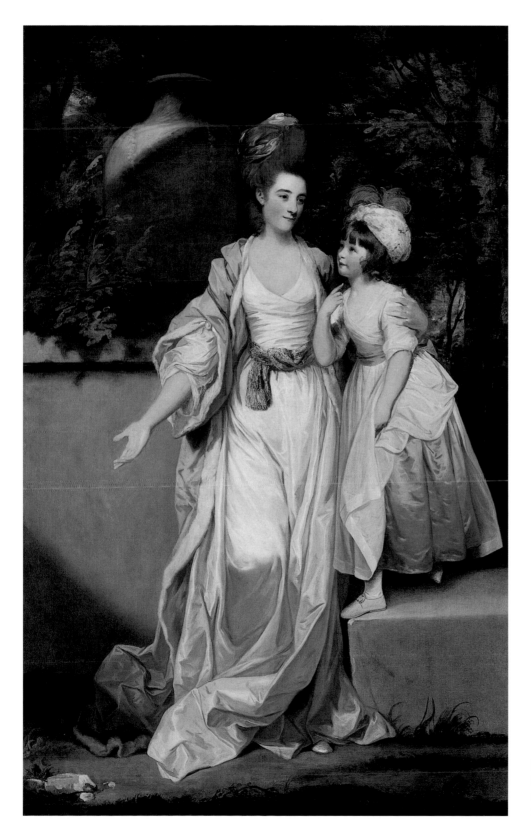

Plate 61. Sir Joshua Reynolds (Plympton, Devonshire 1723-London 1792), *Portrait of Mrs. Jelf Powis and Her Daughter*, 1777, oil on canvas, 93 x 57 in.

Renaissance theory by urging portraitists to rise above particular details "to ennoble the character of a countenance."[14] His own greatest portraits, like those of Titian and Van Dyck before him, are infused with the forms and spirit of the history painting to which he aspired but which he only rarely practiced.

In contrast with other countries in northern Europe, France had embraced the hierarchy of the genres and imposed it through the establishment in 1648 of the Académie Royale de Peinture et de Sculpture. Although that tale is told elsewhere in these pages, we recall the fact here because the practice of portraiture in eighteenth-century France is at variance with that well-established official doctrine. Portrait painting was, in fact, a lively and lucrative affair in a market driven by an expanding population of moneyed classes. For them, the portrait satisfied myriad needs. Above and beyond the sitter's likeness, a dashing, sumptuous picture could represent the wealth, taste, social status (or pretensions), and cultivation of an individual.[15] The very success of the genre can be gauged by the fact that official prices for portraits were lowered more than once, relative to the more highly esteemed history paintings.[16]

Portrait typology in France followed European court tradition from the grandiose, official *portrait d'apparat* to more informal images. Largillière's *Portrait of Pierre Cadeau de Mongazon* (plate 52), in the latter category, shares a directness and spontaneity in approach and handling with a number of portraits of artists he made as early as 1714-15.[17] If this picture looks back to the intimacy of Van Dyck's *Bishop Triest* and other engraved portraits, reminding us of Largillière's early training in Antwerp and England, it also anticipates the increasing informality of French portraiture as the eighteenth century progressed, an informality displayed in the beautiful *Portrait of a Gentleman as a Hunter* by Nattier in the Blaffer Foundation collection (plate 62).

Another development of the later eighteenth century in France was the blurring of distinctions between the genres. Thus Jean-Baptiste Greuze, who had been diverted from history to genre painting by the Académie, gave his paintings of middle-class domestic drama the neoclassical structure, the rhetorical gestures, and the high moral purpose of the *grand genre*.[18] Although Greuze painted some outright portraits, including the masterpiece *La Live de Jully* in Washington, he also could portray actual families as characters to enact his moralizing tales.[19] His *Head of a Young Boy* (plate 63) has that dualism: a realism that seems modeled from life and yet a drama that suggests a narrative purpose.

Subjects of high moral content increased in history painting too, as art in eighteenth-century France moved away from the Rococo and toward the Revolution. In contrast to the erotic mythologies of mid century, Jacques-Louis David (1748-1825) and his generation drew upon ancient history for the examples of virtuous character

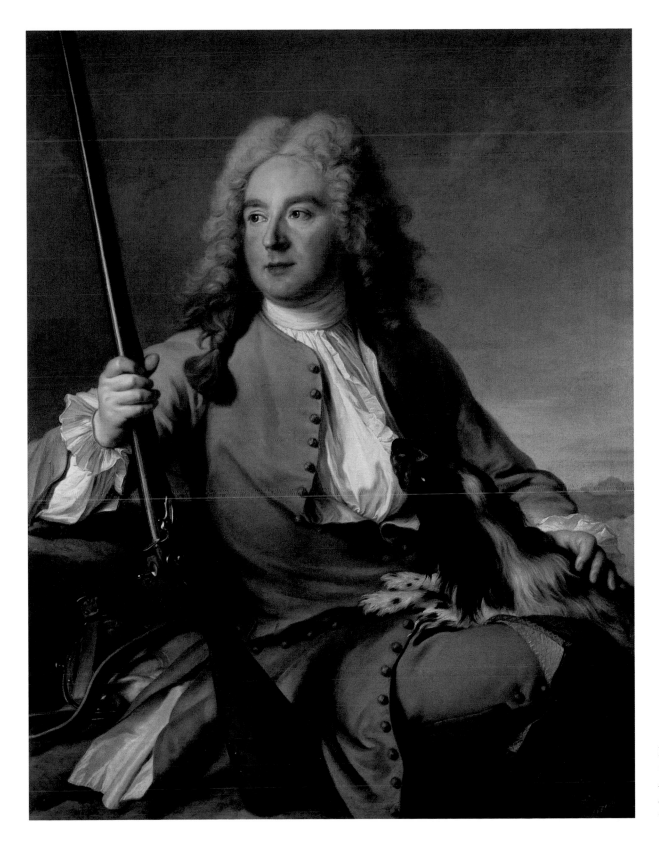

Plate 62. Jean-Marc Nattier
(Paris 1685-Paris 1766),
*Portrait of a Gentleman as a
Hunter*, 1727, oil on canvas,
46⅛ x 36⅞ in.

Plate 63. Jean-Baptiste Greuze (Tournus 1725-Paris 1805), *Head of a Young Boy*, 1760s, oil on canvas, 16⅜ x 13⅛ in.

and conduct that they presented in painting at the Salons of the 1780s. Before and after the Revolution they embraced for painting the promotion of the *exemplum virtutis*. After 1789, however, with works such as David's *Death of Marat* or *The Oath of the Tennis Court*, they began to draw their examples from the bold deeds and sacrifices of people in their own time.[20]

When the spirit of equality swept through the Académie Royale as it did French society at large, portraiture shed her secondary status to take on a new importance and value. On first view, *A Good Deed Is Never Forgotten* (Dallas Museum of Art, fig. 10) by Louis Legrand resembles a genre painting. In fact, like Beach's *The Hand that Was Not Called*, it is a group portrait that records a story, but one with a great moral meaning for French society as a whole. *A Good Deed Is Never Forgotten* commemorates the personal virtue and selflessness of Joseph Cange, a humble clerk at the Prison de la Force. Cange, shown standing with his large family to the left, went to extraordinary lengths to help two strangers, an unjustly-imprisoned aristocrat—now freed—and his wife, shown at the right, who have come to express their gratitude. Painted during the Reign of Terror, when the event occurred, Cange's saga caught the imagination of a people starved for stories of simple human goodness and sparked a series of plays and poems celebrating the triumph of individual virtue. In opposition to the idealizing traditions of the *ancien régime*, it is the very naturalism of this picture that conveys its moral force. Like Cange himself, an awkward hero of exemplary human behavior, the painting is a curious balance of the real and the ideal. Equal parts portraiture and contemporary history, such a work proposes a brave new kind of art for an aspiring democratic society.

Fig. 10. Louis Legrand (Pont-Leveque 1758-Berne 1829), *A Good Deed Is Never Forgotten*, 1796, oil on canvas, 24¾ x 31½ in., the Dallas Museum of Art, Foundation for the Arts Collection, Mrs. John B. O'Hara Fund.

NOTES

[1] POPE-HENNESSY, p. 3.

[2] POPE-HENNESSY, p. 101.

[3] GRASSI, p. 481.

[4] G.B. Armenini, *De' veri precetti della pittura* (Ravenna, 1587), pp. 189-92, reprinted in BAROCCHI, vol. 3, pp. 2749-52. (author's translation).

[5] P. Pino, *Dialogo di pittura* (Venice, 1548) and L. Dolce, *Dialogo della pittura* (Venice, 1557), cited in Luigi Grassi, "Lineamenti per una storia del concetto di ritratto," *Arte Antica e Moderna*, vol. 4 (1961), p. 481.

[6] LOMAZZO, vol. 2, pp. 370-73.

[7] See Lino Moretti, "Portraits," in *The Genius of Venice, 1500-1600*, exh. cat. (London: Royal Academy of Arts, 1983), pp. 32-34.

[8] See Elizabeth Cropper, "The Beauty of Woman: Problems in the Rhetoric of Renaissance Portraiture," in Margaret W. Ferguson, et al., *Rewriting the Renaissance: The Discourses of Sexual Difference in Early Modern Europe* (Chicago: University of Chicago Press, 1986), pp. 175-90.

[9] See John T. Spike, "Ottavio Leoni's Portraits *alla macchia*," in SPIKE 1984, pp. 12-19.

[10] Susan J. Barnes, "The *Uomini Illustri*, Humanist Culture, and the Development of a Portrait Tradition in Early Seventeenth-Century Italy," in BARNES & MELION, pp. 81-92

[11] See JONGH 1986, pp. 124-30, 221.

[12] For the marriage symbolism of the tree and vine in Hals's portrait, which Doncker repeated, see E. Jongh and P.J. Vincken, "Frans Hals als voorzetter van een emblematische traditie," *Oud Holland*, vol. 78 (1961), pp. 118-26.

[13] PRAZ, p. 34.

[14] REYNOLDS, p. 72. See also the introduction by Robert R. Wark, pp. xxxiii.

[15] CONISBEE, pp. 111-13.

[16] CONISBEE, p. 111.

[17] Myra Nan Rosenfeld, *Largillière, Portraitiste du Dix-huitième Siècle*, exh. cat. (Montréal, Musée des Beaux-Arts, 1981), pp. 224-25, fig. VIII and no. 47.

[18] ROSENBLUM, pp. 52-55.

[19] The family of Jean-Joseph de Laborde for *La Mère Bien-Aimée*, for instance (CONISBEE, p. 138).

[20] ROSENBLUM, pp. 81-84

Plate 64. William Hamilton (Chelsea 1751-London 1801), *Edwy and Elgiva: A Scene from Saxon History*, 1793, oil on canvas, 78¼ x 61 in.

"The Greatest Work of the Painter Shall Be History":
History Painting in the Blaffer Collection

COLIN B. BAILEY

> The value and rank of every art is in proportion to the mental
> labour employed in it, or the mental pleasure produced by it.
>
> —Sir Joshua Reynolds, *Discourses on Art, Discourse IV* [1]

Nothing is more foreign or distasteful to modern sensibilities than the concept of the hierarchy of the genres, "that ridiculous heresy," in which the "lower exercises of the art"—still life, landscape, genre, even portraiture—are considered subordinate in value and importance to history painting, the highest form of painting to which the artist may aspire. Heirs to a Romantic tradition that definitively severed genius from any consideration of subject matter—who today would take exception to Caravaggio's dictum that a still life can be painted with the same profundity as an altarpiece?—we find it repugnant to subscribe to an artistic theory that gives pride of place, a priori, to one genre above all others. And so, in an elegant reversal of the traditional hierarchy, an essay devoted to history paintings in the Blaffer Collection appears at the end of this book, deferring to those on still life, landscape, genre, and portraiture.

Yet for artists, patrons, and writers on the arts in Europe during the seventeenth and eighteenth centuries, there was no question that history painting was preeminent.[2] It was the genre of painting that most commanded respect and admiration and whose practitioners were considered to possess the greatest skill and ability, both technical and intellectual. Accordingly, the academies that flourished in Europe in this period organized their teaching around the requirements of this most esteemed, and most difficult, of genres. From their origins, academies in Italy, France, and England had placed particular emphasis on the study of the human figure, both from the live model (*dal nudo*) and after casts of the most famous sculptures of antiquity.[3] Their priority was nothing less than a reaffirmation of the supremacy of history painting, since it was precisely his ability to represent the human figure in expressive narratives that distinguished the history painter from the portraitist or the painter of landscapes.

History painting—Alberti's *istoria*, Félibien's *la peinture d'histoire*—was a term of wider significance than English usage allows. According to one authority on the subject, it included "any fable, ancient or modern, sacred or profane, that history

Plate 65. Pietro Berrittini da Cortona (Cortona 1596-Rome 1669), *St. Constantia's Vision before the Tomb of Sts. Agnes and Emerentiana*, c. 1654, oil on canvas, 38½ x 52 in.

or poetry, esteemed as liberal studies, might provide."[4] Paradoxically, subjects from national or modern history—for example William Hamilton's (1751-1801) *Edwy and Elgiva* (plate 64), a remote episode from Anglo-Saxon legend commissioned to illustrate a deluxe edition of the philosopher David Hume's *History of England from the Invasion of Julius Caesar to the Revolution of 1688*—were rare in high art of the seventeenth and eighteenth centuries: such paintings began to appear with any regularity only after the middle of the eighteenth century, at a time when the primacy of history

painting was first being called into question.[5]

Instead, religious subjects derived from the Old and New Testaments—such as the *Elijah with the Widow of Zarephath and Her Son* attributed to Barent Fabritius (plate 67), or Anton Raphael Mengs's *St. John the Baptist Preaching in the Wilderness* (plate 68), or from the lives of the saints, such as Pietro da Cortona's (*St. Constantia's Vision* (plate 65) or Philippe de Champaigne's *Saint Arsenius Leaving the World* of 1631 (plate 66)—were the history painter's stock-in-trade, although by the eighteenth

Plate 66. Philippe de Champaigne (Brussels 1602-Paris 1674), *St. Arsenius Leaving the World*, 1631, oil on canvas, 23⅜ x 30¼ in.

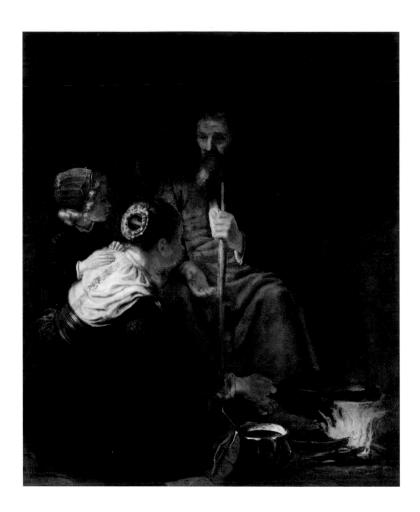

Plate 67. Attributed to Barent Fabritius (Midden Beemster 1624-Amsterdam 1673), *Elijah with the Widow of Zarephath and Her Son*, 1640s-1650s, oil on canvas, 63¼ x 53¼ in.

century such commissions paid rather poorly. The demand for devotional work sustained the history painter at all times, but especially at the beginning of his career: François Lemoyne's recently rediscovered *Adoration of the Magi* (plate 70) was among the works the young artist submitted to gain associate membership of the Academy in December 1716, and was no doubt intended to advertise his proficiency in this field.[6] It is worth noting that, before the establishment of regular Salons or exhibition rooms, commissions from ecclesiastical institutions had the added advantage of permitting the artist to display his work in public, and of helping to secure a reputation. Furthermore, due to the generic nature of the subject of many religious paintings, they could easily be replicated: Sebastiano Ricci's *Last Supper* (plate 69), proudly displaying the artist's debt to Veronese, exists in at least four other versions.[7]

Religious subjects dominate Italian painting of the seventeenth century; the proliferation of still life, landscape, and, to a lesser degree, genre subjects notwithstanding, the Counter-Reformation Church was the principal patron of the arts throughout the century. Thus, such diverse artists as Simon Vouet (plate 71) and Mattia Preti (plate 73), working in the wake of Caravaggio, or, at the end of the century, Luca Giordano (plate 72) would receive their most important commissions for devotional paintings with subjects drawn from the Old and New Testaments.

Equal in status and importance to the "capital subjects of scripture history,"[8] were those taken from classical mythology, which since the Renaissance had provided artists with a rich repertory of subjects. The erotic and decorative possibilities inherent in the loves of the gods as told by Homer, Virgil, and Ovid ensured that there was a constant demand for this sort of history painting throughout the seventeenth and eighteenth centuries. As with religious commissions, mythological painting could assume a variety of forms and functions: in the decoration of princely or patrician residences, the history painter would unify his themes around a given program, and the choice of divinity or fable to be represented might also be determined by iconographic demands. Thus, in Giovanni Battista Tiepolo's resplendent *Juno and Luna* (plate 74), where an imperious Juno is led to the heavens in a carriage pulled by peacocks and

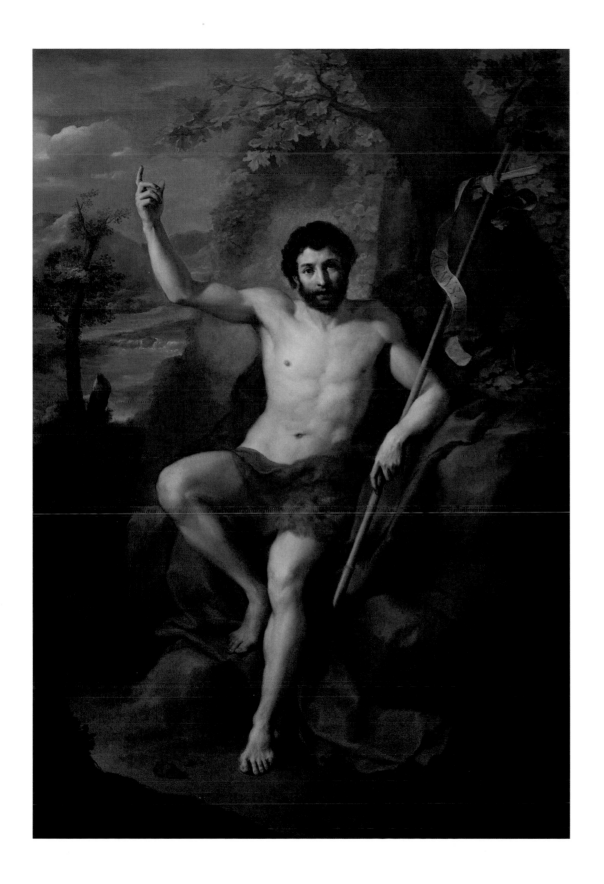

Plate 68. Anton Raphael Mengs (Aussig 1728-Rome 1779), *St. John the Baptist Preaching in the Wilderness*, 1760s(?), oil on canvas, 84½ x 58¼ in.

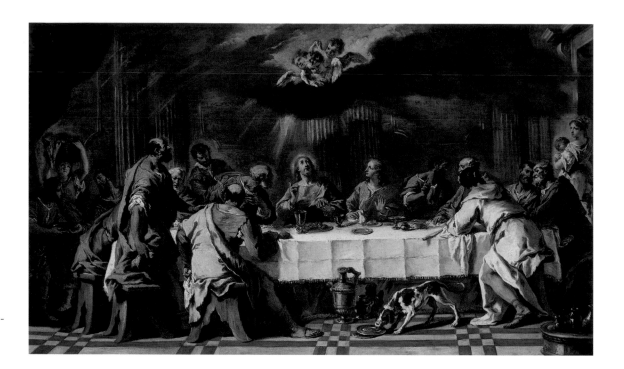

Plate 69. Sebastiano Ricci (Belluno 1659-Venice 1734), *The Last Supper*, after 1719, oil on canvas, 29½ x 49½ in.

cupids, the composition has an emblematic significance that is easily overlooked. *Juno and Luna* relates to two monumental canvases portraying *The Triumph of Amphitrite* and *Bacchus and Ariadne,* which symbolized the elements of Water and Earth respectively; the Blaffer painting was probably intended to symbolize the element of Air.[9] The Four Elements, like the Four Seasons, or the Times of the Day, remained one of the staples of decoration until the end of the eighteenth century, and, although the fourth painting in the series has yet to be identified, it is likely that Tiepolo would have completed this cycle with a mythological subject symbolizing the element of Fire.

A more personal message is encoded in Pierre Mignard's somber *Pan and Syrinx* (plate 75)—a "cabinet picture" to be enjoyed in the privacy of the collector's gallery, since its relatively meticulous finish would have been inappropriate in a work of decoration on the large scale. Mignard is at some pains to imbue this Ovidian tale of desire and deception with a sterner morality, and the mood of his canvas is notably one of sorrow and regret. Indeed, the artist bequeathed an almost identical version of *Pan and Syrinx* to his elder son, a bequest that has been interpreted as an injunction to his heir not to marry without paternal approval, since Mignard's composition emphasizes the havoc and suffering caused by the deity who pursued only his selfish passions.[10]

Along with religious and mythological subjects, the history painter might also expect to treat episodes from ancient Greek and Roman history, as Jacques Sablet in

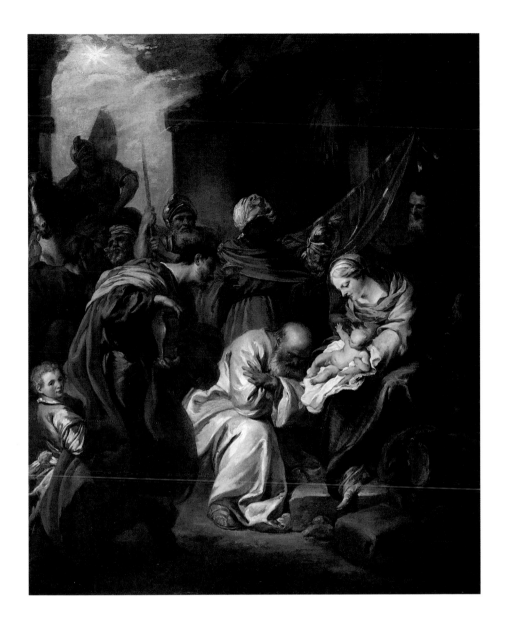

Plate 70. François Le Moyne (Paris 1688-
Paris 1737), *The Adoration of the Magi*,
1716, oil on canvas, 39¼ x 32 in.

his *Death of Pallas* of 1778 (plate 79); he might tackle themes from Tasso's *Jerusalem Delivered* or Ariosto's *Orlando Furioso*, masterpieces of Italian Renaissance literature and the only "modern" texts to acquire the status of classical epic by the seventeenth century. Francesco Mola, who was president of the Accademia di San Luca in Rome from July 1662, painted *Erminia and Vafrino Mourning the Dying Tancred* (plate 76) as recounted by Tasso in canto XIX of *Jerusalem Delivered*.[11] The noble crusader Tancred has just ended a bloody combat with the Saracen Hercules, Argante, whose dead body can be seen in miniature in the left background. Badly wounded, Tancred is held up by his loyal squire Vafrino, while Erminia, princess of Antioch, flings her-

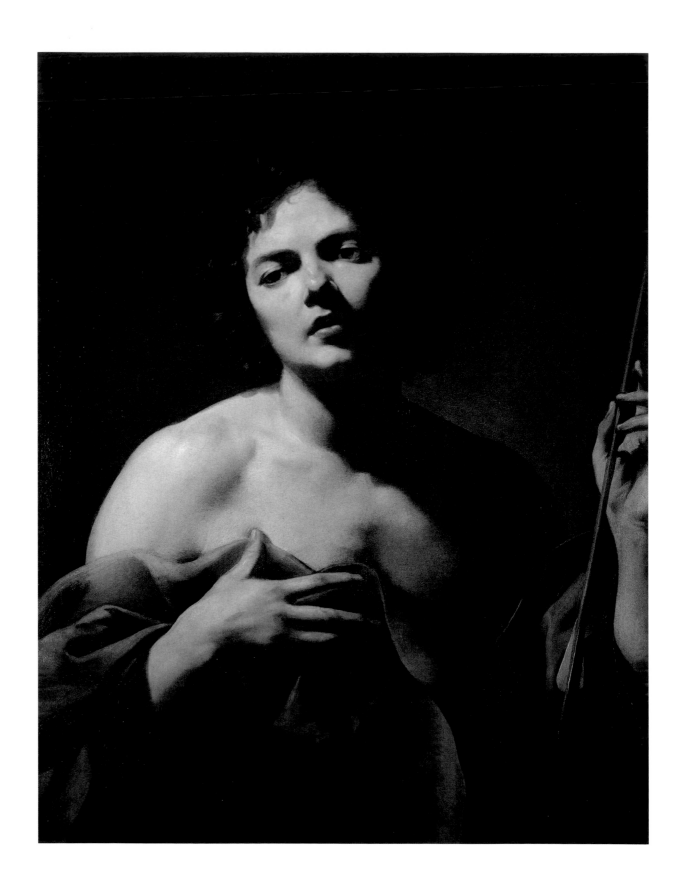

Plate 71. Simon Vouet
(Paris 1590-Paris 1649),
St. Sebastian, c. 1618-20,
oil on canvas, 37¾ x 29 in.

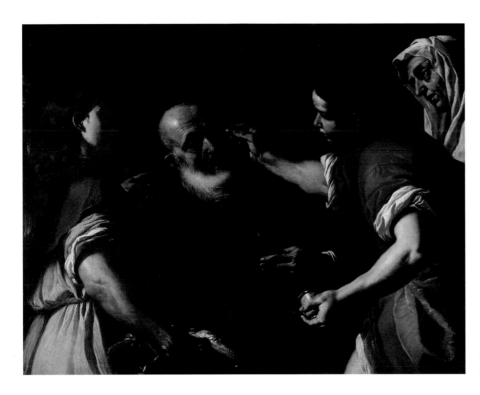

Plate 72. Mattia Preti (Taverna 1613-
Malta 1699), *Tobias Healing His
Father's Blindness*, 1630-40,
oil on canvas, 41 x 51 in.

Plate 73. Luca Giordano (Naples 1634-
Naples 1705), *The Battle of Israel and
Amalek*, c. 1692, oil on canvas,
36¾ x 48¾ in.

self at the Christian hero with whom she has fallen hopelessly
in love, and whom she takes for dead. Mola represents quite
precisely the moment in which Vafrino, after having seen
Tancred open his eyes for an instant, reassures Erminia, "This
man is not dying, let him first be cured and then be wept."[12]

Finally, the history painter might paint allegories, which
served to dignify a branch of learning or thought. A good
example of this last category, which had played an important
role in the Jesuits' teaching program, but whose popularity was
already on the wane by the end of the seventeenth century, is
Laurent de La Hyre's elegant and noble *Allegory of Scientific
Experiment* (plate 77).[13] Here the artist has represented this
branch of learning in accordance with the conventions laid out
in Cesare Ripa's *Iconologia*, a widely used emblem book first
published in 1593 that went through ten editions by the middle
of the eighteenth century. Ripa described Experience as "an old
Matron . . . with a scroll inscribed RERUM MAGISTRA (Mistress of
All Things), a flame pot and a touch stone at her feet."[14]
Although La Hyre takes poetic license in presenting the allegor-

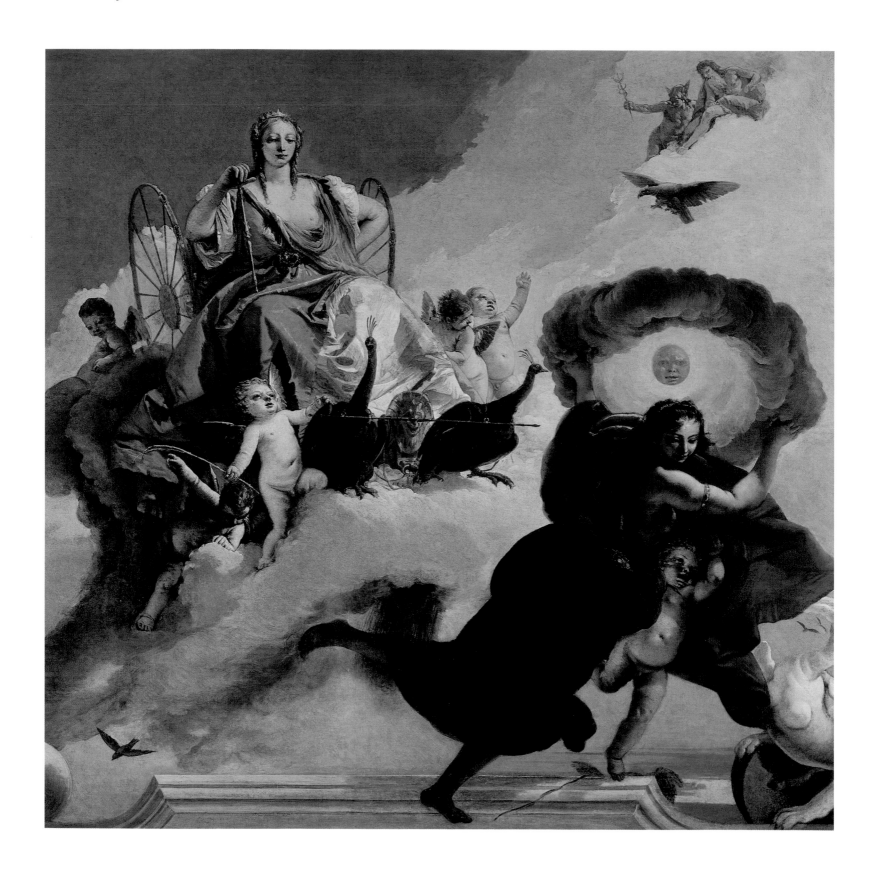

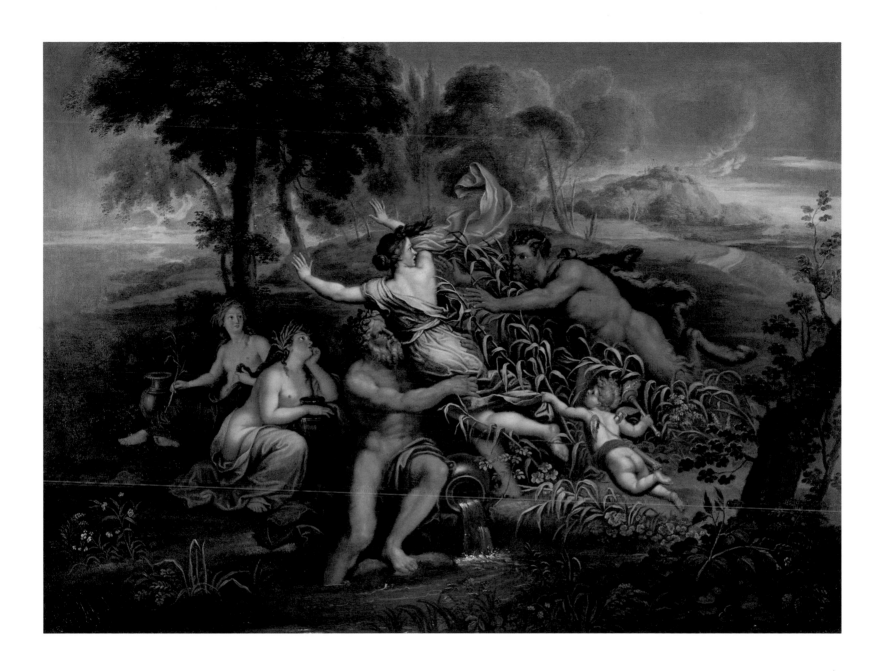

Plate 75. Pierre Mignard (Troyes 1612-
Paris 1695), *Pan and Syrinx*, c. 1688-90,
oil on canvas, 28¾ x 38½ in.

Plate 74. Giovanni Battista Tiepolo
(Venice 1696-Madrid 1770),
Juno and Luna, 1735-45,
oil on canvas, 83¾ x 90¾ in.

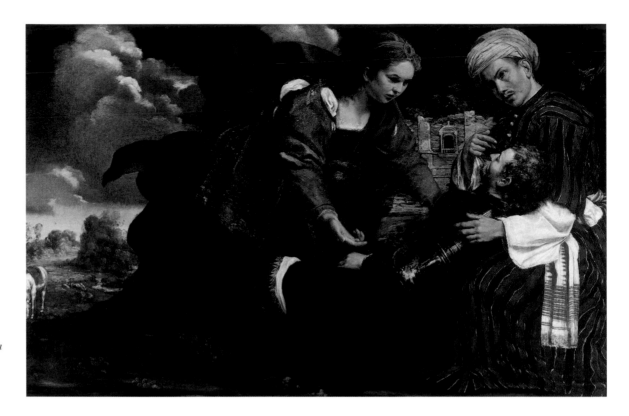

Plate 76. Pier Francesco Mola
(Coldrerio 1612-Rome 1666), *Erminia
and Vafrino Mourning the Dying
Tancred*, 1655-60, oil on canvas,
52¾ x 80¼ in.

ical figure as an attractive woman, he otherwise translates Ripa's attributes into paint
punctiliously.

In conclusion, some general points may be made concerning the theory and
practice of history painting in Europe during the seventeenth and eighteenth centuries.
First, as is clear from the different types of subject that constituted the history painter's
repertory, religion and mythology enjoyed equal status as the most important themes.
Félibien, spokesman for the recently founded French Academy, encouraged the painter
"to treat both history and mythology [*la fable*], to represent the grandest events like
the Historian, and to treat agreeable subjects in the manner of the Poets."[15] Thus, the
tendency to associate history painting exclusively with subjects of a moralizing or
didactic nature would only develop at a later stage of the Academy's history; it was
not part of aesthetic or academic theory until the 1760s. Following a distinction first
made in Aristotle's *Poetics*, it was understood that in painting histories or mythologies,
the artist should represent a selected and improved nature, based on his mastery of
the human form, but informed also by his study of art, and always disdaining minute
detail or base realism.[16] Thus Ricci's expressive *Hercules Killing the Centaur Nessus*
(plate 78), with its closely observed male anatomies, consciously looks to the work of
a great master of the previous century; his figure of Hercules, brandishing the club,

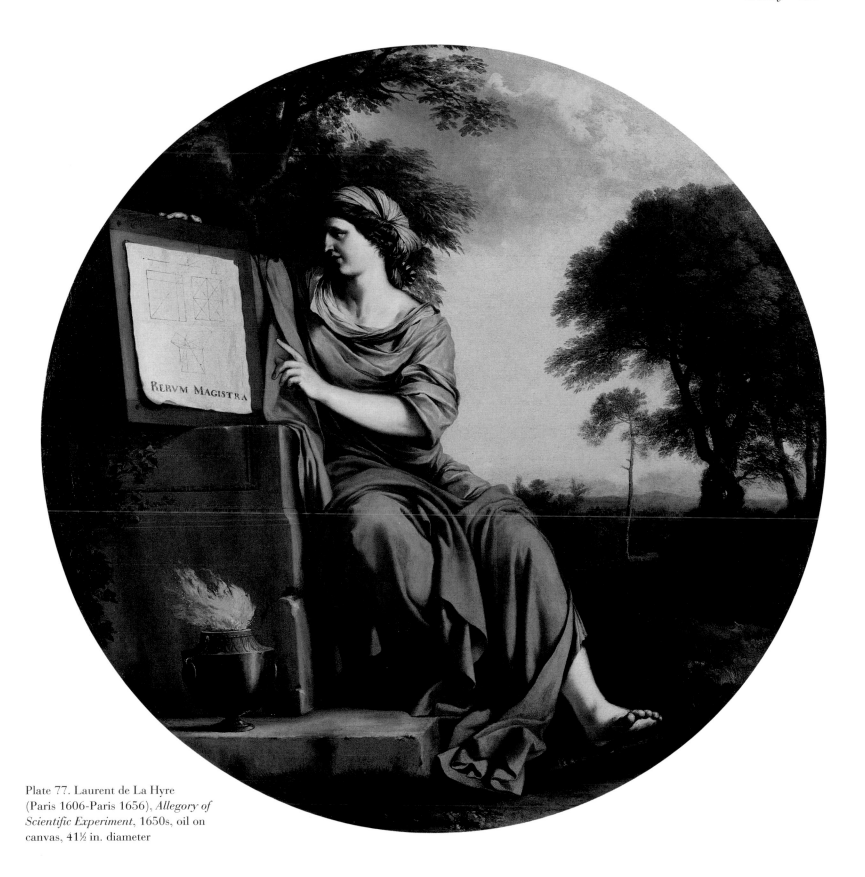

Plate 77. Laurent de La Hyre
(Paris 1606-Paris 1656), *Allegory of
Scientific Experiment*, 1650s, oil on
canvas, 41½ in. diameter

Plate 78. Sebastiano Ricci (Belluno 1659-Venice 1734), *Hercules Killing the Centaur Nessus*, c. 1700, oil on canvas, 35½ x 44½ in.

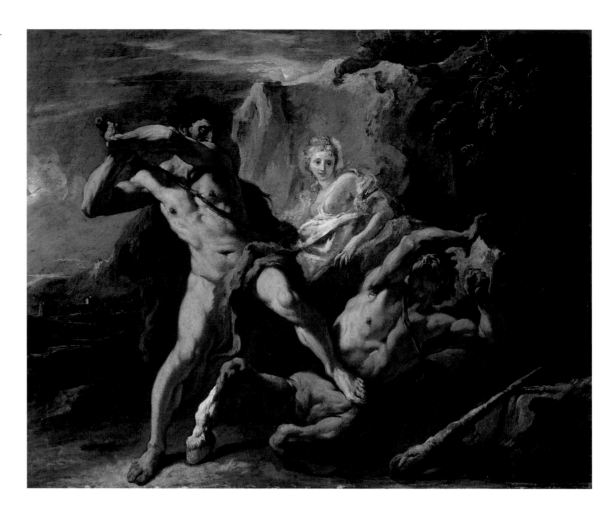

Fig. 11. Guido Reni (Calvenzano 1575-Bologna 1642), *Hercules and the Hydra*, 1620, oil on canvas, 102¾ x 77⅞ in., Musée du Louvre ©R.M.N.

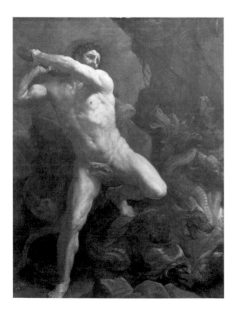

derives from Guido Reni's *Hercules and the Hydra* (fig. 11).[17] Direct quotation from venerated models of art—which today might be disdained as plagiarism—was an essential part of the making of a history painting; it attested to the painter's breadth of knowledge. If we recognize that manner was as important as matter—within the strict canon of subjects deemed appropriate—it should seem less surprising that mythological and literary themes ranked equally with religion and history. The esteem for profane subjects, nobly treated, was furthermore reflected in the honors accorded those artists who made something of a specialty of the genre, such as François Boucher and Jean-Baptiste-Marie Pierre, whose mythological paintings are exhibited here (plates 80, 81, and 82). Boucher and Pierre, as well as Lemoyne, were not only full professors, but each held the office of First Painter to the King, the most prestigious appointment that could be conferred on members of the French Academy.[18]

Secondly, although from the time of Alberti it had been assumed that the only painter worthy of the name was the painter of "histories," the concept of a hierarchy

of the genres entered academic theory relatively late; it was articulated by Félibien only in 1669, two decades after the foundation of the Académie Royale de Peinture et de Sculpture, and only thereafter did it become a central tenet in writing on the arts in France and England.[19] Before this time, however, and particularly in Italy, discourse on the art of painting tended to be more frankly polemical in asserting the distinction between painters and craftsmen, and in stressing the liberal nature of the artist's endeavors. It is noteworthy, for example, that until 1598 Bolognese painters were enrolled in the guild of sword cutlers, saddlers, and scabbard makers, and that, until the creation of the French Academy some fifty years later, all the artists working in Paris, unless they enjoyed royal dispensation, were obliged to belong to the Corporation of Painters and Sculptors, a medieval guild founded in 1391.[20] To separate what Reynolds would later call the "intellectual dignity" of the art from the mere "mechanism of painting,"[21] theorists insisted that artists, no less than poets, derived inspiration primarily from the mind; that, in order to represent in a single image those subjects that poets and historians had been able to portray sequentially, artists had to be especially well versed in literature, philosophy, and history.[22] "Invention" was the painter's greatest gift: and by this term should be understood not the capacity to create new or original subjects, but the ability to interpret anew the myths and legends consecrated by tradition in such a way that their beauty, pathos, and drama were translated onto the canvas with no diminishment.

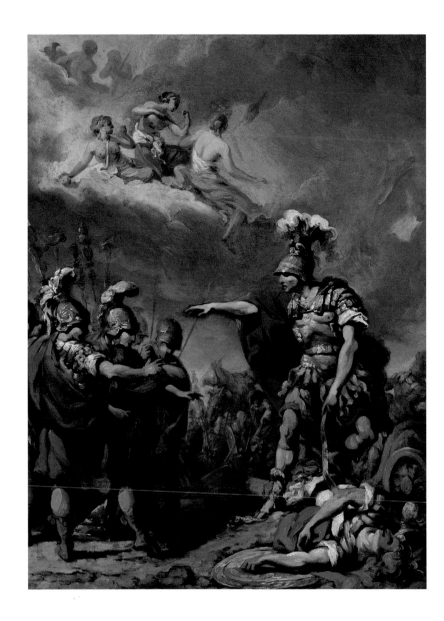

Plate 79. Jacques Henri Sablet (Morges 1749-Paris 1803), *The Death of Pallas*, 1778, oil on paper mounted on canvas, 18½ x 13⅜ in.

"It is through Invention that Painting aspires to equality with Poetry, and attracts the esteem of the most worthy persons," stated Roger de Piles.[23] Indeed, the notion that painting and poetry were sister arts, which had originated with Horace, was one of the most dearly held beliefs in the period under discussion. A spirited watercolor by Charles-Joseph Natoire (fig. 12), probably made in the mid 1740s as a design for a frontispiece engraving, testifies to the enduring power of Horace's simile of the sisterhood of the arts. Inside an ideal academy, aspiring history painters copy

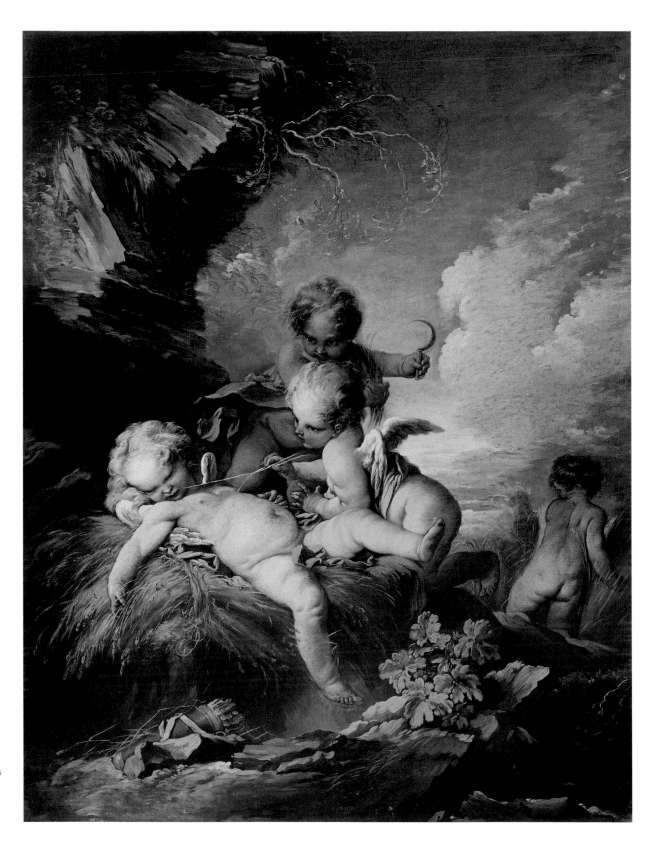

Plate 80. François Boucher (Paris
1703-Paris 1770), *The Cherub
Harvesters*, c. 1733-34, oil on
canvas, 49½ x 37½ in.

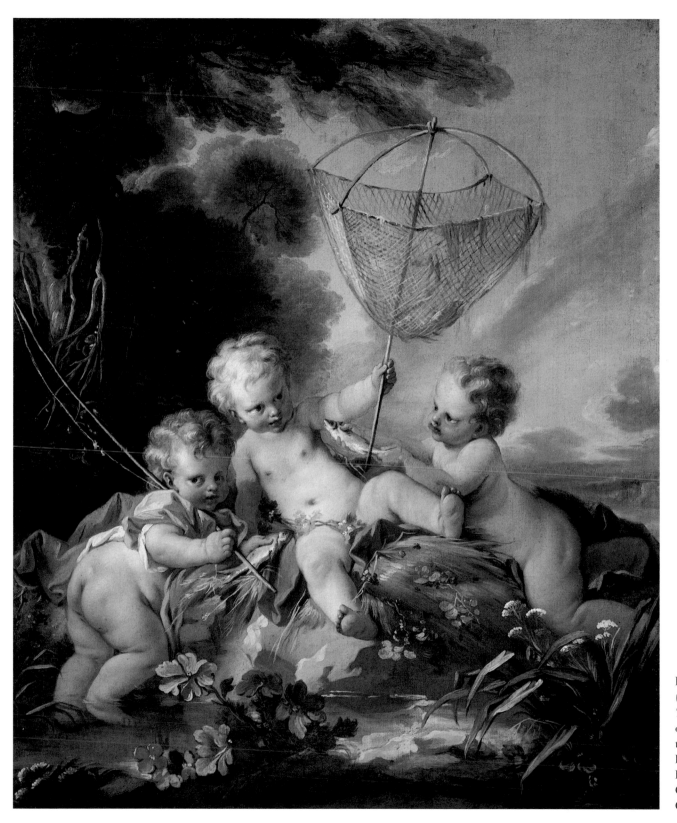

Plate 81. François Boucher
(Paris 1703-Paris 1770),
The Fishermen, c. 1744,
oil on canvas, 37⅛ x 31 in.,
the Museum of Fine Arts,
Houston, the Robert Lee
Blaffer Memorial
Collection, Gift of Sarah
Campbell Blaffer, 58.15.

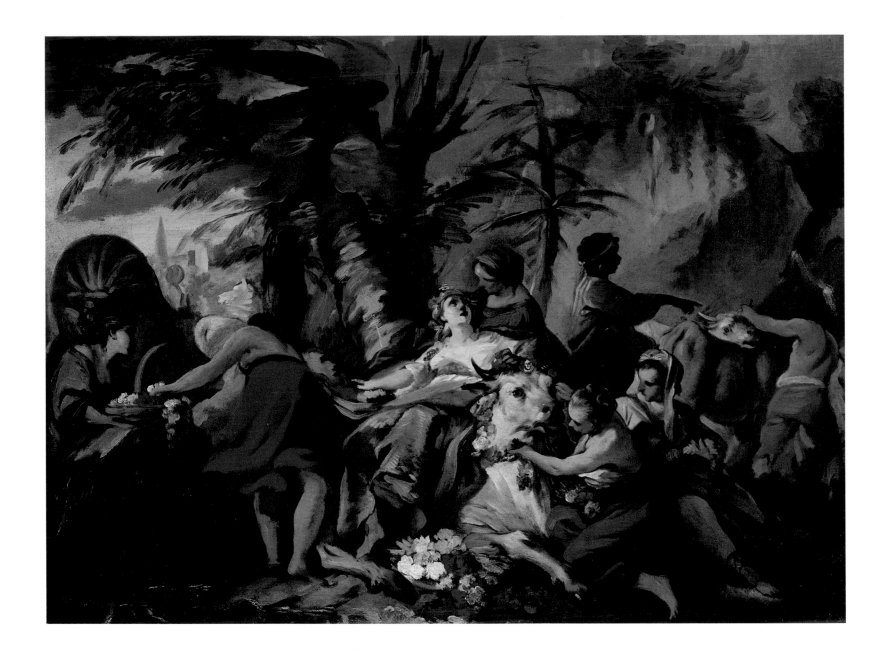

Plate 82. Jean-Baptiste-Marie Pierre
(Paris 1713-Paris 1789), *The Rape
of Europa*, 1759, oil on canvas,
20¼ x 27⅛ in.

from the live model, who may be glimpsed in the center of the composition just behind Minerva's plumed helmet. They are surrounded by the most famous antiquities: the Venus de' Medici on the left, the Hercules Farnese on the right. Minerva, the goddess of Wisdom, palette and paintbrush in hand, chases away blind Ignorance and furious Envy, while the Three Graces correct a young student's drawing. The figure of Fame appears from the swags of drapery at upper right, blowing a trumpet and holding a crown of laurel in her left hand. A group of putti at lower left put the finishing touches to a noble bust of Louis XV, Horace's UT PICTURA POESIS inscribed on the tablet

beside them.

Such is the glory of the history painter, Natoire seems to be saying: knowledge, learning, and technical skill may be forged through constant study, royal protection, and divine inspiration. The rhetoric and symbolism of this drawing may seem far removed from any twentieth-century notion of artistic genius, just as many of the history paintings in the Blaffer Collection may seem equally distant and inaccessible to modern eyes. Yet if we make the effort to familiarize ourselves with the episodes represented in these canvases—once common currency for a wide and diverse audience, now remembered, if at all, only by specialists and scholars; if we move beyond formal analysis toward an appreciation of the process by which such narrative paintings were constructed; and if we recognize in the ambitions of the history painter the dignity and nobility he sought for his craft, then we too may be stirred by Alberti's resonant statement: *"Grandissima opera del pictore sara l'istoria"*—"The greatest work of the painter shall be history."[24]

Fig. 12. Charles-Joseph Natoire (Nîmes 1700-Castel Gandolfo 1777), *Ut Pictura Poesis*, 1745, watercolor, 21 x 14¾ in., Private Collection

NOTES

[1] REYNOLDS, p. 57.

[2] WITTKOWER, pp. 42-43, and for France, most recently, Pierre Rosenberg in BAILEY, pp. 14-16.

[3] The best summary remains PEVSNER, pp. 60-80 *passim*. See also the many interesting essays in "Academies of Art between Renaissance and Romanticism" *Leids Kunsthistorisch Jaarboek* V-VI (1986-87), especially pp. 1-44.

[4] LEE, p. 211.

[5] The standard reference for the introduction of medieval subjects into European art is PUPIL, pp. 185-225.

[6] BORDEAUX, 1984, p. 29, where the preparatory drawing in the Louvre is cited, but not the painting itself.

[7] PIGNATTI, p. 182.

[8] For Reynolds' comments, see REYNOLDS, p. 58.

[9] PIGNATTI, p. 190-92. Tiepolo's *Triumph of Amphitrite* is in the Gemäldegalerie, Dresden; *Bacchus and Ariadne* was last recorded in a private collection in New York.

[10] This connection, first made by Jean-Claude Boyer, is discussed most recently in BAILEY, p. 102.

[11] Mola made something of a specialty of subjects from Tasso's *Jerusalem Delivered*; for the most thorough account, in which the Blaffer painting is not mentioned, see R.W. Lee, "Mola and Tasso," in *Studies in Renaissance and Baroque Art Presented to Anthony Blunt* (London and New York: Phaidon, 1967), pp. 136-42.

[12] TASSO, canto XIX, verse 111, p. 431.

[13] ROSENBERG & THUILLIER, p. 319, no. 297.

[14] From the English translation of Ripa published in London, 1709, where the emblem of "Esperienza" is rendered as "Experience." See Cesare Ripa, *Iconologia* (rpt. New York: Garland, 1976), p. 28.

[15] FÉLIBIEN, V, p. 311, "Preface," "il faut représenter de grandes actions comme les Historiens ou des sujets agréables comme les Poètes."

[16] MAHON, p. 127; LEE, p. 209.

[17] For the history of Reni's Hercules series, see PEPPER, pp. 239-40.

[18] For a discussion of this office see the introductory essay by G.S. Sainty in BAILEY 1985, pp. 9-19.

[19] In the preface to the *Conférences* published in 1669, Félibien went so far as to attribute a religious significance to the hierarchy of the genres: "Since the figure of man is God's most perfect creation on earth, it follows that he who paints the human form and thus imitates our Lord, is a great deal more excellent than all the other painters." (author's translation).

[20] PEVSNER, pp. 68-69, 82-84.

[21] REYNOLDS, pp. 43, 63.

[22] This argument was neatly put by the English connoisseur and theorist Jonathon Richardson in his "Essay on the Theory of Painting," first published in 1715: "Painting has another advantage over words; and that is, it pours ideas into our minds, words only drop them. The whole scene opens at one view, whereas the other way lifts up the curtain by little and little." In RICHARDSON, p. 2.

[23] PILES, p. 62: "c'est par elle que la Peinture marche de pas égal avec la poesie et c'est elle principalement qui attire l'estime des personnes les plus estimables."

[24] From Alberti's *Della pittura* (1436), as quoted by LEE, p. 211.

Checklist of the Exhibition

Note: Unless otherwise indicated, all works are in the collection of the Sarah Campbell Blaffer Foundation.

Dimensions are in inches, followed by centimeters. All works are oil on canvas unless otherwise indicated.

STILL LIFE

Pietro Paolo Bonzi
Cortona 1576-Rome 1640
The Fruit Market, c. 1625-30
47½ x 71 (120 x 180)
Plate 13

Pierre van Boucle
Antwerp(?) c. 1600-Paris 1673
Still Life with Carp and Pike, 1652
31½ x 39¾ (80 x 101)
Plate 15

Jean-Baptiste Siméon Chardin
Paris 1699-Paris 1779
Still Life with Joint of Lamb, 1730
15¾ x 12¹³⁄₁₆ (40 x 32.5)
Plate 22

Pieter Claesz.
Burg-Steinfurt (Germany) 1597-
Haarlem 1661
Still Life with Meat, c. 1650
Oil on panel
36⅝ x 55 (93.4 x 139.7)
Plate 14

Alexandre-François Desportes
Champigneulle 1661-Paris 1743
Still Life with Dog and Game, 1710
32¼ x 40⅜ (81.8 x 102.5)
Plate 18

Jan Fyt
Antwerp 1611-Antwerp 1661
Hounds Resting from the Chase, c. 1640s
49 x 74 (124.5 x 188)
Plate 16

Melchior d'Hondecoeter
Utrecht 1636-Amsterdam 1695
The Crow Exposed, c. 1680(?)
67 x 83¼ (170.2 x 211.5)
Plate 17

Pierre-Nicolas Huilliot
Paris 1674-Paris 1751
Still Life with Silver and Gold Vessels, Fruit, and Flowers, 1718
78 x 64 framed (198.1 x 162.6)
Plate 12

Jean-Baptiste Oudry
Paris 1686-Beauvais 1755
Allegory of Europe, 1722
63¾ x 59¾ (162 x 152)
Plate 19

Jean-Baptiste Oudry
Paris 1686-Beauvais 1755
Allegory of Asia, c. 1722
63¾ x 59¾ (162 x 152)
Collection of E. Joseph Hudson, Jr.
Plate 20

Jean-Baptiste Oudry
Paris 1686-Beauvais 1755
Still Life with Hare and Sheldrake, 1740
34⅜ x 28 (88 x 71)
Collection of E. Joseph Hudson, Jr.
Plate 21

LANDSCAPE

Ludolf Bakhuyzen
Emden 1631-Amsterdam 1708
The Dutch Man-of-War "De Gouden Leeuw" on the River Y near Amsterdam, 1674
48¼ x 61⅛ (123 x 158.7)
Plate 26

Antonio Canal, called Canaletto
Venice 1697-Venice 1768
Grand Canal, Entrance Looking West, c. 1730
19½ x 29 (49.6 x 73.6)
The Museum of Fine Arts, Houston, the Robert Lee Blaffer Memorial Collection, gift of Sarah Campbell Blaffer, 56.2
Plate 31

Antonio Canal, called Canaletto
Venice 1697-Venice 1768
Grand Canal, Looking Southwest from near Rialto Bridge, c. 1730
19¹¹⁄₁₆ x 28¾ (49.7 x 73.0)
The Museum of Fine Arts, Houston, the Robert Lee Blaffer Memorial Collection, gift of Sarah Campbell Blaffer, 55.103
Plate 32

Aelbert Cuyp
Dordrecht 1620-Dordrecht 1691
Horsemen before Ubbergen Castle, c. 1650s
Oil on panel
23 x 29 (58.5 x 73.7)
Plate 29
[Alan Chong, the Cleveland Museum of Art,
has proposed an attribution to Abraham van
Calraet (Dordrecht 1642-Dordrecht 1722)]

Gaspard Dughet, also called Gaspard Poussin
Rome 1615-Rome 1675
The Rest on the Flight into Egypt, 1653-57
28 ½ x 38⅜ (72.5 x 97.5)
Plate 23

Thomas Gainsborough
Sudbury 1727-London 1788
Coastal Scene with Shipping and Cattle,
c. 1781-82
30 x 25 (76 x 63.5)
Plate 37

Sawrey Gilpin
Scaleby 1733-Brompton 1807
and Philip Reinagle
Edinburgh(?) 1749-Chelsea 1833
*The Display on the Return to Dulnon Camp,
August, 1786*, 1786(?)
44¼ x 64 (112.5 x 162.5)
Plate 40

Jan van Goyen
Leiden 1596-The Hague 1656
View of Dordrecht from the Northeast, 1647
37¼ x 57½ (94.6 x 146)
Plate 27

Francesco Guardi
Venice 1712-Venice 1793
Regatta at the Rialto Bridge, 1770s
30½ x 49½ (70.8 x 125.7)
Plate 33

Jean-Baptiste Huet
Paris 1769-Paris 1823
*Landscape with Shepherdesses and
Fishermen*, 1793
21¼ x 25⅝ (54 x 65)
Plate 36

Charles-François Lacroix de Marseille
Paris, Avignon, or Marseilles c.1720-Berlin
1782
An Italian Port Scene, 1770
35½ x 72 (90.2 x 182.9)
Plate 25

Johannes Lingelbach
Frankfurt-am-Main 1622-Amsterdam 1674
*A Capriccio View of Rome with the Castel
Sant' Angelo*, 1655
33¼ x 46 (84.3 x 118)
Plate 30

Michele Marieschi
Venice 1710-Venice 1743
*View of the Dogana and Santa Maria della
Salute*, n.d.
21¼ x 32½ (54 x 82.5)
Plate 34

George Morland
London 1763-London 1804
View at Enderby, Leicestershire, 1792
34 x 46 (86.5 x 117)
Plate 35

Jacob van Ruisdael
Haarlem 1628/9-Amsterdam(?) 1682
Landscape with Cornfields, 1670s
21¾ x 24⅞ (55.2 x 62.8)
Plate 28

Richard Wilson
Penegoes, Wales 1713/14-Mold, Wales 1782
The White Monk, c. 1760-65
36 x 51¼ (76 x 130)
Plate 24

Joseph Wright of Derby
Derby 1734-Derby 1797
Dovedale by Moonlight, c. 1785
24½ x 29¼ (62 x 74.5)
Plate 38

Joseph Wright of Derby
Derby 1734-Derby 1797
*Italian Landscape with Mountains and a
River*, c. 1790
20½ x 30½ (54.5 x 77.5)
Plate 39

GENRE PAINTING

Bonaventure De Bar
Paris 1700-Paris 1729
Fête Champêtre, late 1720s
7 x 11½ (17.8 x 29.2)
Plate 49

Jean-Honoré Fragonard
Grasse 1732-Paris 1806
A Boy Leading a Cow, c. 1760s
21¼ x 26 (54.0 x 66.0)
Plate 50

Dirck Hals
Haarlem 1591-Haarlem 1656
The Merry Company, 1630s
Oil on panel
20½ x 32¾ (52.1 x 83.2)
Plate 41

Nicolas Lancret
Paris 1690-Paris 1743
The Captive Bird, c. 1730
11⅝ x 15⅝ (29.5 x 39.7)
Plate 48

Jean-Baptiste Leprince
Metz 1734-Saint Denis-du-Port 1781
The Tartar Camp, c. 1765
69 x 87 ¾ (175 x 223)
Plate 51

Philippe Mercier
Berlin 1689-London 1760
A Girl Pulling on Her Stocking, c. 1745-50
55 x 40 (127 x 101.5)
Plate 52

Frans van Mieris the Elder
Leiden 1635-Leiden 1681
with Willem van Mieris(?)
Leiden 1662-Leiden 1747
Interior with Figures Playing Tric-trac, 1680
30½ x 26½ (77.5 x 67.4)
Plate 42

Adriaen van Ostade
Haarlem 1610-Haarlem 1685
Interior with Drinking Figures and Crying Children, 1634
12¼ x 16⅞ (31.1 x 42.6)
Plate 43

Egbert van der Poel
Delft 1621-Rotterdam 1664
A Skating Scene, 1656
Oil on panel
14 x 19 (35.6 x 48.2)
Plate 46

Jan Steen
Leiden 1626-Leiden 1679
The Twelfth Night Feast, 1670s
26⅞ x 38⅞ (68.6 x 101.6)
Plate 45

Plate 45
David Teniers the Younger
Antwerp 1610-Brussels 1690
Soldiers Playing Dice, c. 1630s
Oil on copper laid on panel
21½ x 28⅞ (54 x 73)
Plate 44

Philips Wouwerman
Haarlem 1619-Haarlem 1668
Soldiers Plundering a Village, 1660s
Oil on panel
18⅜ x 25⅛ (46.8 x 64.7)
Plate 47

PORTRAITURE

Thomas Beach
Abbey Milton 1738-Dorchester 1806
The Hand that Was Not Called, 1775
58 x 74½ (146.5 x 189)
Plate 60

Ferdinand Bol
Dordrecht 1616(?)-Amsterdam 1680(?)
Portrait of a Man (Lord Hebdon?), 1659
52½ x 42 (133.3 x 106.8)
Plate 56

Paolo Caliari, called Veronese
Verona 1528-Venice 1588
Portrait of a Lady as St. Agnes, 1580s
34 x 29½ (84 x 72.5)
Plate 53

Nathaniel Dance
London 1735-Winchester 1811
*Sir Francis and Lady Dashwood
at West Wycomb Park*, 1776
28 x 35⅞ (71 x 91)
Plate 59

Herman Mijnerts Doncker
c. 1620-working in Haarlem 1653-after 1656
Family Group, 1644
73⅞ x 99⅛ (187.6 x 252)
Plate 58

Anthony Van Dyck
Antwerp 1599-London 1641
*Portrait of Antoine Triest, Bishop of Ghent
(1576-1655)*, c. 1627
31½ x 25⅛ (80 x 64.1)
Plate 55

Jean-Baptiste Greuze
Tournus 1725-Paris 1805
Head of a Young Boy, 1760s
16⅜ x 13⅛ (41.5 x 33.5)
Plate 63

Frans Hals
Antwerp 1584-Haarlem 1666
Portrait of a Woman, 1650
33⁵⁄₁₆ x 27⁵⁄₁₆ (84.6 x 69.2)
The Museum of Fine Arts, Houston, the
Robert Lee Blaffer Memorial Collection, gift of
Sarah Campbell Blaffer, 51.3
Plate 57

Italian, Roman school
Pope Gregory the Great, c. 1620(?)
49½ x 38¼ (126 x 97)
Plate 54

Nicolas Largillière
Paris 1656-Paris 1746
Portrait of Pierre Cadeau de Mongazon,
c. 1720(?)
32 x 25½ (81.3 x 64.8)
Plate 52

Paolo de Matteis
Cilento 1662-Naples 1728
*Allegory of the Consequences of the Peace of
Utrecht*, after 1714
30 x 40 (77.2 x 106.6)
Plate 11

Jean Marc Nattier
Paris 1685-Paris 1766
Portrait of a Gentleman as a Hunter, 1727
46⁵⁄₁₆ x 36⁵⁄₁₆ (117 x 90)
Plate 62

Sir Joshua Reynolds
Plympton, Devonshire 1723-London 1792
Portrait of Mrs. Jelf Powis and Her Daughter,
1777
93 x 57 (236.5 x 145)
Plate 61

HISTORY PAINTING

François Boucher
Paris 1703-Paris 1770
The Cherub Harvesters, c. 1733-34
49½ x 37½ (125.7 x 95.3)
Plate 80

François Boucher
Paris 1703-Paris 1770
The Fishermen, c. 1744
37⅛ x 31 (94 x 78.5)
The Museum of Fine Arts, Houston, the
Robert Lee Blaffer Memorial Collection,
gift of Sarah Campbell Blaffer, 58.15
Plate 81

Bartolomeo Cavarozzi
Viterbo c. 1590-Rome 1625
Virgin and Child with Angels, c. 1620
61⅛ x 49¼ (155.3 x 125.1)
Plate 2

Philippe de Champaigne
Brussels 1602-Paris 1674
St. Arsenius Leaving the World, 1631
23⅝ x 30¼ (60 x 76.8)
Plate 66

Pietro Berrettini da Cortona
Cortona 1596-Rome 1669
*St. Constantia's Vision before the Tomb of
Sts. Agnes and Emerentiana*, c. 1654
38½ x 52 (97 x 132)
Plate 65

Benjamin-Gerritsz. Cuyp
Dordrecht 1612-Dordrecht 1652
Annunciation to the Shepherds, after 1633
33 x 45⅝ (83.8 x 116)
Plate 3

Michel Dorigny
Saint-Quentin 1617-Paris 1665
Hagar and the Angel, c. 1645-50
55¾ x 42⅜ (141.5 x 101.7)
Plate 4

Attributed to Barent Fabritius
Midden Beemster 1624-Amsterdam 1673
*Elijah with the Widow of Zarephath and Her
Son*, 1640s-1650s
63¼ x 53¼ (160.8 x 135.3)
Plate 67

Henri-Antoine de Favanne
London 1668-Paris 1752
Athena Protecting Alexander before Darius,
c. 1725
37 x 49½ (94 x 126)
Plate 7

Flemish school
The Triumph of Neptune and Amphitrite,
mid 17th century
Oil on metal laid on board
21½ x 28¼ (54.5 x 72.5)
Plate 5

Luca Giordano
Naples 1634-1705
The Battle of Israel and Amalek, c. 1692
36¾ x 48¾ (93 x 124)
Plate 73

William Hamilton
Chelsea 1751-London 1801
Edwy and Elgiva: A Scene from Saxon History,
1793
78¼ x 61 (190.5 x 155)
Plate 64

Laurent de La Hyre
Paris 1606-Paris 1656
Allegory of Scientific Experiment, 1650s
41½ diameter (105.4)
Plate 77

Jean Lemaire
Dammartin 1598-Gaillon 1659
Mercury and Argus, 1650s(?)
29 x 38 (73.7 x 96.5)
Plate 10

Anton Raphael Mengs
Aussig 1728-Rome 1779
*St. John the Baptist Preaching in the
Wilderness*, 1760s(?)
84½ x 58¼ (215 x 148)
Plate 68

Pierre Mignard
Troyes 1612-Paris 1695
Pan and Syrinx, c. 1688-90
28¾ x 38½ (71.9 x 97.4)
Plate 75

Pier Francesco Mola
Coldrerio 1612-Rome 1666
*Erminia and Vafrino Mourning the Dying
Tancred*, 1655-60
52¾ x 80¼ (134 x 206)
Plate 76

François Le Moyne
Paris 1688-Paris 1737
The Adoration of the Magi, 1716
39¼ x 32 (99.7 x 81.3)
Plate 70

Jean-Baptiste-Marie Pierre
Paris 1713-Paris 1789
The Rape of Europa
20¼ x 27⅛ (51.5 x 69)
Plate 82

Mattia Preti
Taverna 1613-Malta 1699
Tobias Healing His Father's Blindness,
1630-40
41 x 51 (104 x 129.5)
Plate 72

Sebastiano Ricci
Belluno 1659-Venice 1734
Hercules Killing the Centaur Nessus, c. 1700
35½ x 44½ (90 x 112)
Plate 78

Sebastiano Ricci
Belluno 1659-Venice 1734
The Last Supper, after 1719
29½ x 49½ (75 x 125.7)
Plate 69

Jacopo Robusti, called Tintoretto
Venice 1518-Venice 1594
The Mocking of Christ, c. 1580s
61⅞ x 41¼ (157 x 105)
Plate 1

Jacques Henri Sablet
Morges 1749-Paris 1803
The Death of Pallas, 1778
Oil on paper mounted on canvas
18½ x 13⅜ (47 x 34.1)
Plate 79

Ippolito Scarsella, called Lo Scarsellino
Ferrara 1551-Ferrara 1620
Martyrdom of St. Venantius of Camerino,
c. 1600
56¾ x 79½ (144 x 202)
Plate 9

Giovanni Battista Tiepolo
Venice 1696-Madrid 1770
Juno and Luna, 1735-45
83¾ x 90¾ (213 x 231.1)
Plate 74

Carle Van Loo
Nice 1705-Paris 1765
Mars and Venus, c. 1730
32 x 26 (81.3 x 66)
Plate 6

Simon Vouet
Paris 1590-Paris 1649
St. Sebastian, c. 1618-20
37¾ x 29 (96 x 73.5)
Plate 71

Benjamin West
Springfield 1738-London 1820
*The Son of Man in the Midst of the Seven
Golden Candle Sticks, Appearing to John the
Evangelist, and Commanding Him to Write
(John Called to Write the Revelation)*, 1797
Oil on five sheets of paper mounted on canvas,
itself mounted on panel, 57½ x 25¼ (143.5 x
64) on panel 57⅞ x 26½
(147 x 67.5)
Plate 8

Selected Bibliography

ALBERTI — Alberti, Leon Battista. *Della pittura*. Edited by L. Mallé. Florence, 1950.

BAILEY 1985 — Bailey, Colin B. *The First Painters of the King, French Royal Taste from Louis XIV to the Revolution*. Exh. cat. New York: Stair Sainty Matthiesen, 1985.

BAILEY 1991 — Bailey, Colin B. *The Loves of the Gods: Mythological Painting from Watteau to David*. Exh. cat. Fort Worth: Kimbell Art Museum; Paris: Reunion des musées nationaux, 1991.

BARNES & MELION — Barnes, Susan J., and Walter S. Melion, eds. *Cultural Differentiation and Cultural Identity in the Visual Arts*. Studies in the History of Art, no. 27. Washington, DC: National Gallery of Art, 1989.

BAROCCHI — Barocchi, Paola, ed. *Scritti d'arte del cinquecento*. 3 vols. Milan and Naples: Riccardo Ricciardi, 1971- 77.

BERGSTROM — Bergstrom, Ingvar. *Dutch Still Life Painting in the Seventeenth Century*. Translated by Christina Hedstrom and Gerald Taylor. New York: T. Yoseloff, 1956.

BLANKERT — Blankert, Albert. *Gods, Saints, and Heroes: Dutch Painting in the Age of Rembrandt*. Exh. cat. Washington, DC: National Gallery of Art, 1980.

BORDEAUX — Bordeaux, Jean-Luc. *François Lemoyne and His Generation*. Neuilly-sur-Seine: Arthena, 1984.

BRIGANTI — Briganti, Guiliano. *The View Painters of Europe*. Translated by P. Waley. London: Phaidon Press, 1970.

BUTLIN — Butlin, Martin. *Aspects of British Painting 1550-1800, from the Collection of the Sarah Campbell Blaffer Foundation*. Houston: Sarah Campbell Blaffer Foundation, 1988.

CLARK — Clark, Kenneth. *Landscape into Art*. London: John Murray, 1949. Rev. and rpt. Beacon Paperbacks, 1961.

CONISBEE — Conisbee, Philip. *Painting in Eighteenth-Century France*. Ithaca: Cornell University Press, 1981.

FARÉ — Faré, Michel. *La Nature morte en france, son histoire et son evolution du XVIIe au XXe siècle*. Geneva: P. Cailler, 1962.

FÉLIBIEN — Félibien, André. *Entretiens sur les vies et les ouvrages des plus excellens peintres anciens et modernes; avec la vie des architectes*. Rpt. Gregg P. Farnborough (Hants), 1967.

CHATELET & REYNAUD — *Etudes d'art francais offertes a Charles Sterling*. Compiled by Albert Chatelet and Nicole Reynaud, Paris: Presses universitaires de France, 1975.

FRIEDLÄNDER — Friedländer, Max. *Landscape, Portrait, Still-Life; Their Origin and Development*. Translated by R.F.C. Hull. New York: Philosophical Library, 1950.

GRASSELLI & ROSENBERG — Grasselli, Margaret Morgan and Pierre Rosenberg. *Watteau 1684-1721*. Exh. cat. Washington, DC: National Gallery of Art, 1984.

HARGROVE — Hargrove, June Ellen, ed. *The French Academy: Classicism and Its Antagonists*. Newark: University of Delaware Press, 1990.

HOLMES — Holmes, Mary Tavener. *Nicolas Lancret 1690-1743.* Exh. cat. New York: Harry N. Abrams in association with The Frick Collection, 1991.

JONGH — Jongh, E. de. *Portretten van echt en trouw: huwelijk en gezin in de Nederlandse kunst van de zeventiende eeuw.* Exh. cat. Zwolle: Waanders; Haarlem: Frans Halsmuseum, 1986.

JORDAN — Jordan, William B. *Spanish Still Life and the Golden Age 1600-1650.* Exh. cat. Fort Worth: Kimbell Art Museum, 1985.

LAGERLOF — Lagerlof, Margaretha Rossholm. *Ideal Landscape: Annibale Carracci, Nicolas Poussin, and Claude Lorrain.* New Haven: Yale University Press, 1990.

LEE — Lee, R.W. *"Ut Pictura Poesis*: The Humanistic Theory of Painting," *Art Bulletin* vol. 22, 1940, pp. 197-269.

LOMAZZO — Lomazzo, Giovanni Paolo. *Trattato dell'arte della pittura, scultura ed architecttura.* 3 vols. Rome: Presso S. Del-Monte, 1844.

MAHON — Mahon, Dennis. *Studies in Seicento Art and Theory.* Westport, CT: Greenwood Press, 1971.

MARTINEAU & HOPE — Martineau, Jane and Charles Hope, eds. *The Genius of Venice, 1500-1600.* Exh. cat. New York: Harry N. Abrams, 1984.

MUNHALL — Munhall, Edgar. *Jean-Baptiste Greuze / 1725-1805.* Exh. cat. Edited by Joseph Focarino. Hartford, CT: The Wadsworth Atheneum, 1976.

OPPERMAN — Opperman, Hal N. *J.B. Oudry.* Exh. cat. Fort Worth: Kimbell Art Museum, 1983.

PEPPER — Pepper, D. Stephen. *Guido Reni: A Complete Catalogue of His Works.* New York: New York University Press, 1984.

PEVSNER — Pevsner, Nicolas. *Academies of Art, Past and Present.* New York: Da Capo, 1973.

PIGNATTI — Pignatti, Terisio. *Five Centuries of Italian Painting 1300-1800.* Houston: Sarah Campbell Blaffer Foundation, 1985.

PILES — Piles, Roger de. *Cours de Peinture par principes.* Paris: Jacques Estienne, 1708.

PIROVANO — Pirovano, Carlo, ed. *La Natura morta in Italia.* Milan: Electa, 1989.

POPE-HENNESSY — Pope-Hennessy, John. *The Portrait in the Renaissance.* Princeton: Princeton University Press, 1963.

PRAZ — Praz, Mario. *Conversation Pieces.* University Park: Pennsylvania State University Press, 1971.

PUPIL — Pupil, François. *Le Style Troubadour, ou, la nostalgie du bon vieux temps.* Nancy: Presses universitaires de Nancy, c. 1985.

REYNOLDS — Reynolds, Sir Joshua. *Discourses on Art.* Edited by Robert R. Wark. New Haven and London: Yale University Press, 1975.

RICHARDSON — Richardson, Jonathan. *The Works of Mr. Jonathan Richardson.* London: R. Davies, 1773.

ROSENBERG — Rosenberg, Jakob; Seymour Slive and E. H. ter Kuile. *Dutch Art and Architecture: 1600 to 1800.* Baltimore: Penguin Books, 1966.

ROSENBERG & THUILLIER — Rosenberg, Pierre and Jacques Thuillier. *Laurent de la Hyre 1606-1656: L'homme et l'oeuvre.* Geneva: Skira, 1988.

ROSENBLUM — Rosenblum, Robert. *Transformations in Late Eighteenth Century Art.* Princeton: Princeton University Press, 1974.

SALERNO — Salerno, Luigi. *Still Life Painting in Italy, 1560-1805.* Translated by Robert Erich Wolf. Rome: Ugo Bozzi Editore, 1984.

SCHNEIDER — Schneider, Norbert. *The Art of Still Life: Still Life Painting in the Early Modern Period.* Cologne: Benedikt Taschen, 1990.

SEGAL — Segal, Sam. *A Prosperous Past: The Sumptuous Still Life in the Netherlands 1600-1700.* Exh. cat. Edited by William B. Jordan. Translated by P.M. van Tangeren. The Hague: SDU Publishers, 1989.

SPIKE 1983 — Spike, John T. *Italian Still Life Paintings from Three Centuries.* Exh. cat. Florence: Centro Di, 1983.

SPIKE 1984 — Spike, John T. *Baroque Portraiture in Italy: Works from North American Collections.* Exh. cat. Sarasota, Florida: The John and Mable Ringling Museum of Art, 1984.

SPIKE 1986 — Spike, John T. *Giuseppe Maria Crespi and the Emergence of Genre Painting in Italy.* Exh. cat. Fort Worth: Kimbell Art Museum, 1986.

STECHOW — Stechow, Wolfgang. *Dutch Landscape Painting of the Seventeenth Century.* London: Phaidon Press, 1966.

STECHOW & COMER — Stechow, Wolfgang and Christopher Comer. "The History of the Term Genre." *Allen Memorial Museum Bulletin,* vol. 33, no. 2 (1975-76), pp. 89-94.

STERLING — Sterling, Charles. *Still Life Painting from Antiquity to the Present Time.* Translated by James Emmons. New York: Universe Books, 1959.

SUTTON — Sutton, Peter C. et al. *Masters of Seventeenth-Century Dutch Genre Painting.* Exh. cat. Boston: Museum of Fine Arts, 1981.

TASSO — Tasso, Torquato. *Jerusalem Delivered.* Translated and edited by Ralph Nash. Detroit: Wayne State University Press, 1987.

VROOM — Vroom, Nicolaas Rudolph Alexander. *A Modest Message as Intimated by the Painters of the "Monochrome Banketje."* Schiedam: Interbook International, 1980.

WITTKOWER — Wittkower, Rudolf. *Art and Architecture in Italy 1600 to 1750.* Baltimore: Penguin Books, 1958. Rev. integ. ed., 1973.

WRIGHT — Wright, Christopher. *The Golden Age of Painting: Dutch, Flemish, German Paintings, Sixteenth-Seventeenth Centuries, from the Collection of the Sarah Campbell Blaffer Foundation.* San Antonio: Trinity University Press, 1981.

Edited by Mary Christian
Designed by Peter Layne

Photography by Michael Bodycomb, Tom DuBrock,
Hickey-Robertson, Paul Hester, Allen Mewbourn,
and Malcolm Varon.

Library of Congress Cataloging in Publication Data

Shackelford, George T.M., 1955-
 Masterpieces of baroque painting from the Sarah Campbell Blaffer
Foundation / George T.M. Shackelford.
 p. cm.
 Exhibition catalog.
 Includes bibliographical references.
 ISBN 0-89090-056-6 : $55.00. —
ISBN 0-89090-055-8 (paper) : $35.00
 1. Painting, Baroque—Exhibitions. 2. Painting, Modern—17th-18th
centuries—Exhibitions. 3. Sarah Campbell Blaffer Foundation—
Exhibitions. I. Museum of Fine Arts, Houston. II. Sarah Campbell
Blaffer Foundation. III. Title.
ND177.S5 1992
759.04`6`0747641411—dc20 92-28864
 CIP